THE
ULTIMATE
GAMERS
COOKBOOK

THE ULTIMATE GAMERS COOKBOOK

RECIPES FOR AN EPIC GAME NIGHT

Julie
Thank you so much!
Edet Andy

INSIGHT
EDITIONS

SAN RAFAEL · LOS ANGELES · LONDON

CONTENTS

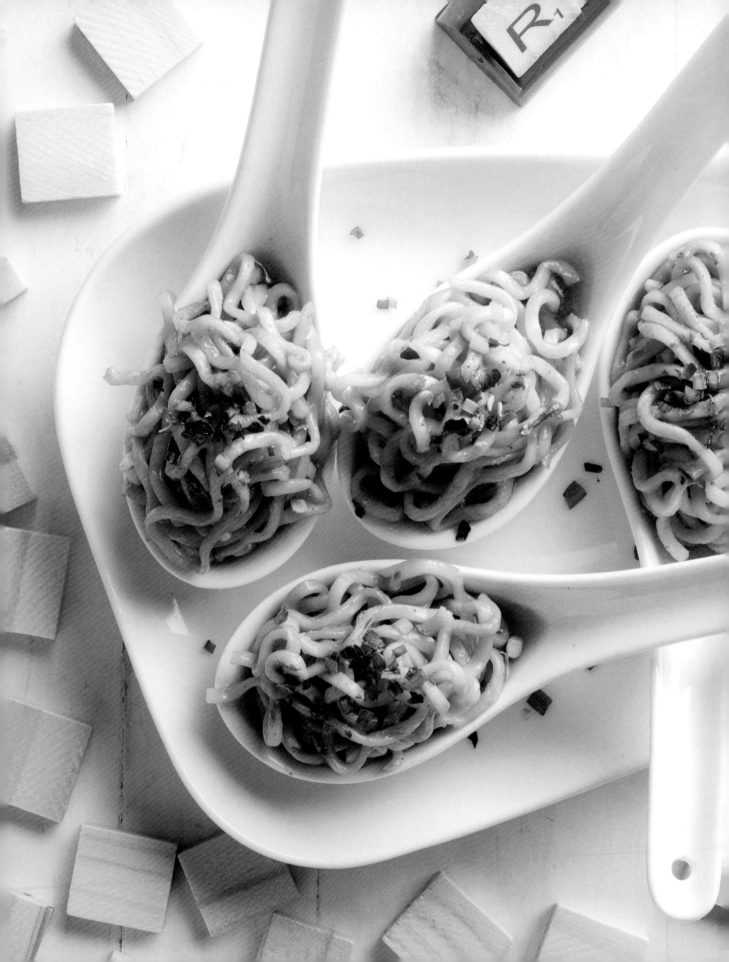

PLAYER'S TUTORIAL

This book was crafted to inspire anyone getting together with friends to play games to make sure the experience is accompanied by great food. Each recipe should give you the ability to tailor the game night you're hosting no matter your skill level, your guest count, and, most importantly, your budget.

The goals are simple:

1. Utilize ingredients that are easy to obtain at most markets

2. Provide cooking methods anyone can follow

3. Inspire themed events so you look like a total boss when you host

Let me be clear, the recipes and directions I have put together are created for ease, simplicity, speed, fun, and keeping your fingers as clean as possible. I wanted to make sure anyone who uses this book learns not only fun ways to engage with food but also recipes that you can alter and adjust on your own. You'll also notice that I provide alternative options for vegans, vegetarians, and "I seriously don't have time to make that from scratch" types.

Whether you are getting together to jump online, sitting on the couch with a partner, putting together an evening with a few friends, preparing to host as a Dungeon Master, or staging a LAN, I have options for you!

Most folks have a recipe book in their home they never use. Quite a few folks gift recipe books that are never opened. This book is meant to be passed to your friends and family. Use it to put the onus on "the next time you get together," and most importantly, you should feel the freedom to "mod" these recipes at every step. Make each recipe your own!

PATCH NOTES

Each recipe provides an estimated Prep Time, which includes non-active times like marinating, and Cook Time, which is active cooking or baking time. Rest Time indicates resting after cooking, dough rest, or chill times.

DIFFICULTY GUIDE:
THE KARDACHEF SCALE

When it comes to recipes, there can be millions of variations for a single one. Based on the experience of the person cooking, the level of effort and difficulty can vary widely from pure amateur to world-renowned skill. All the recipes in this book can be completed by anyone, no matter their skill level.

To provide a simple, easy-to-follow metric on the skill required for each recipe, I present to you the "KardaChef Scale."

TYPE NULL:

This person truly cannot manage food for themselves. They rely on others to make meals or scrape by with premade meals. They have little interest in food beyond sustenance and genuinely focus on survival, at best. These are the people who bring cups to potlucks.

TYPE 0:

This person can put together palatable food, currently using crude tools and cooking methods to create meals. They have little skill but can find the energy to create simple fare.

TYPE 1:

A recipe follower, this person learned to cook at home or is self-taught but generally sticks to staple dishes and meal prep. They are likely only cooking for a single person or a small family.

TYPE 2 (AKA "FOODIE"):

This person experiments with cooking methods, recipes, and techniques and has the ability to adapt new recipes to their tastes. This individual owns a wide range of cooking materials, equipment, and spices and likely worked in food service.

ROLL FOR INITIATIVE

We've all heard the legend of Lord Sandwich asking for meat between two slices of bread to sustain his gambling streak. Today, no one on Earth argues with the fact that a sandwich is a global staple. However, arguments rage over what *actually counts* as a sandwich. In this section, all the recipes follow the classic definition of sandwich: something edible between two pieces of bread or—in one case—surrounded by bread. I am confident that my take on sandwiches will cause the next global conflict.

Thyme to DDDDuel Decker

Your opening draft is often the most important moment of a game. How you make your opening moves sets the pace for the entire match, so when it comes to sandwiches, serving what is arguably the best sandwich ever as an opening snack to guests is solid early-stage strat.

KardaChef Level: Type 0 · Prep Time: 20 minutes

Cook Time: 30 minutes · Yield: 12 sandwiches

¼ cup (60 milliliters) mayonnaise

1 tablespoon (15 milliliters) Dijon mustard

¼ teaspoon (1.4 grams) kosher salt

¼ teaspoon (1.4 grams) garlic powder

6 slices sandwich bread or 6 Hawaiian rolls

16 ounces (28 grams) white cheddar cheese, shredded

6 slices of your favorite ham

3 tablespoons (43 grams) unsalted butter, melted or softened

Toothpicks for serving

Chopped fresh thyme for garnish

1. Preheat your oven to 400°F (204°C).

2. In a small bowl, mix the mayonnaise, mustard, salt, and garlic powder. Set this mix aside.

3. On a flat surface or sheet pan, arrange the sliced bread or rolls next to one another and cover each completely with the Dijon-mayonnaise mix.

4. Add the shredded cheese to cover the spread and top with the ham. Reserve ⅓ of the cheese for sprinkling on top of the sandwiches.

5. Top the sandwiches with the remaining slices of bread or rolls.

6. Spread about 1 teaspoon (4.7 grams) butter on each side of the sandwiches and arrange on a foil-lined cookie sheet. Sprinkle the top with the remaining cheese.

7. Bake for about 10 to 12 minutes and then flip.

8. Cook until golden brown on the top, about 15 to 18 minutes.

9. Carefully trim off the crust.

10. Eat the crust.

11. Cut each sandwich into 4 small squares and skewer each square with a toothpick.

12. Garnish with fresh thyme and serve immediately.

You can use whatever type of ham you prefer, but thinly sliced country ham and serrano ham work well.

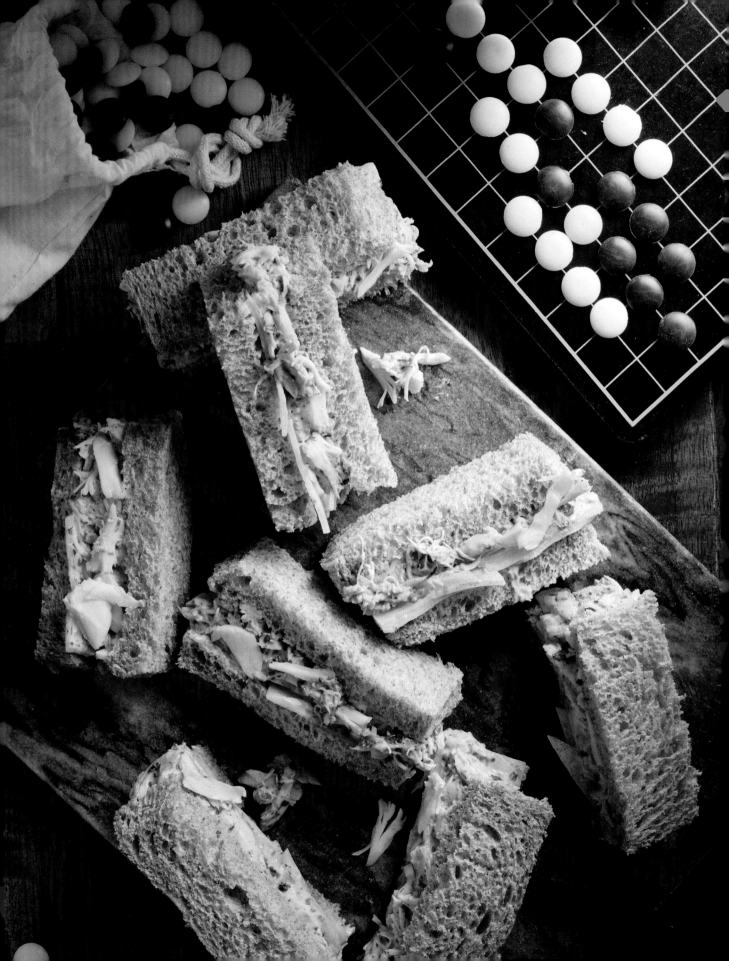

FRENZIED FINGER SANDWICHES

Keeping your fingers clean is the golden rule no matter what game you're playing. These tiny sandwiches are dedicated to waging the battle against sticky or greasy fingers. You don't need white gloves and a fancy cloth to enjoy this series of sandwiches, but it wouldn't hurt to make sure you have a napkin. Don't forget to eat the crusts.

CUCUMBER CRAB

KardaChef Level: Type 0 • Prep Time: 15 minutes • Yield: 9 sandwiches

½ cup (60 grams) cream cheese

3 tablespoons (10 grams) finely chopped onion or shallot

½ bunch (25 grams) parsley, finely chopped

One 8-ounce (226-gram) can jumbo lump crab meat

½ cup (120 milliliters) lemon juice

1 tablespoon (28 grams) Old Bay seasoning

⅛ teaspoon (1 gram) black pepper

6 slices white or wheat bread

1 cucumber

Salt to taste

1. Put the cream cheese, onion, and chopped parsley in a bowl and mix to combine. Note that the shallot will provide a more subtle aroma with a mild flavor, and classic onion will be more pronounced and aromatic.

2. Once combined, fold in your crab meat, lemon juice, Old Bay, and black pepper.

3. Spread the cream cheese mix onto 6 slices of bread.

4. Peel the cucumber and thinly slice with a potato peeler or mandoline.

5. Place the sliced cucumber on top of the herbed cream cheese on three of the bread slices, taking care to ensure that it is evenly distributed.

6. Sprinkle with salt to taste.

7. Place the other three slices of bread, cream cheese side down, on top of the cucumber to make a three sandwiches.

8. Carefully remove the crusts and slice the sandwich into three equal rectangles.

9. Eat the crust.

TURKEY APPLE

KardaChef Level: Type 0 • *Prep Time: 20 minutes* • *Yield: 12 sandwiches*

½ cup (120 milliliters) mayonnaise

2 tablespoons (30 milliliters) lemon juice

⅛ teaspoon (1 gram) black pepper

6 slices white bread

12 slices smoked or roasted turkey

6 slices smoked Gouda cheese

1 apple, thinly sliced

1. In a small bowl, mix the mayonnaise, lemon, and black pepper and set aside.

2. Lay out 6 slices of bread.

3. Spread the mayonnaise mix on each slice of bread.

4. Stack the sliced turkey, cheese, and apple slices evenly distributed on 3 slices of bread.

5. Complete the sandwich with the other slice of bread.

6. Cut the crust off each sandwich.

7. Eat the crust.

8. Cut the sandwich into square quarters.

VEGETABLE SPREAD

KardaChef Level: Type 1 • Prep Time: 20 minutes
Cook Time: 45 minutes • Yield: 6 sandwiches

2 red bell peppers, sliced into rings

1 medium onion, sliced into rings

4 cloves garlic, crushed

1 small zucchini, sliced

1 tablespoon (15 milliliters) olive oil

One 8-ounce (226-gram) block cream cheese

Salt to taste

White pepper to taste

4 slices white or wheat bread

1. Heat oven to 400°F (204°C). Line a half sheet pan with foil and set aside.

2. Place the bell pepper, onion, garlic, zucchini, and olive oil in a medium mixing bowl and toss until the vegetables are coated.

3. Spread the vegetables evenly on the prepared half sheet pan and roast, tossing occasionally, until the vegetables are soft and beginning to turn brown around the edges, about 45 minutes.

4. Remove from the oven and cool completely.

5. Transfer the vegetables to a food processor along with the cream cheese and process until well combined and spreadable; do not process until completely smooth.

6. Season with salt and pepper to taste.

7. Spread the cream cheese mix onto 4 slices of bread, then complete the sandwich.

8. Carefully remove the crusts and slice the sandwiches into three equal rectangles.

9. Eat the crust.

Strawberry Cheese

KardaChef Level: Type 0 · Cook Time: 10 minutes · Rest Time: 15 minutes

Prep Time: 10 minutes · Yield: 8 sandwiches

Balsamic Reduction

2 cups (473 milliliters) balsamic vinegar

½ cup (100 grams) brown sugar

Sandwiches

½ cup (100 grams) strawberry jam

14 large strawberries, thinly sliced

2 tablespoons (35 milliliters) balsamic reduction

4 slices whole grain bread

8 slices Swiss cheese

1 teaspoon (5 grams) unsalted butter, softened

1. In a medium pot, add the sugar and balsamic vinegar and place over medium heat.

2. Stir occasionally until thickened, about 10 minutes.

3. Cool for at least 15 minutes and set aside.

4. Mix strawberry jam with the balsamic reduction.

5. Lay out 2 slices of bread. On one side, layer 2 slices of cheese.

6. Top with the strawberry mix, add sliced strawberries, and then top with the other 2 slices of bread.

7. Place a medium nonstick pan on medium-low heat and spray with cooking spray.

8. Butter the outside of the bread and place sandwiches into the pan.

9. Cook on each side until golden brown and cheese melts, about 3 minutes.

10. Remove the sandwiches from the heat, then cut the crust off each sandwich.

11. Eat the crust.

12. Cut the sandwich into square quarters.

Shortcut

You can often find balsamic reduction at the grocery store and skip the reducing step if you're short on time.

PALADIN PIZZA PUFFS

While pizza is a simple fix for any gathering, it's clearly breaking the clean finger handbook. The pizza puff is here to give the flexibility of pizza without the mess. Plus, toppings are versatile and easy to mix and match in each bake.

KardaChef Level: Type 2 • Prep Time: 20 minutes
Cook Time: 25 minutes • Yield: 12 Puffs

Tomato Fondue Sauce

1 cup (225 grams) canned tomato sauce

½ cup (160 milliliters) heavy cream

¼ cup (25 grams) grated Parmesan cheese

1 bunch fresh basil

Pizza Puffs

1 cup (120 grams) all-purpose flour

1 teaspoon (4 grams) baking powder

1 tablespoon (14 grams) Italian seasoning

1 teaspoon (4 grams) salt

1 teaspoon (4 grams) garlic powder

1 cup (235 milliliters) heavy cream

1 egg, beaten

1 cup (120 grams) shredded mozzarella cheese

½ cup (60 grams) shredded Parmesan cheese

1 cup (230 grams) pepperoni, diced

To Make the Tomato Fondue Sauce

1. In a medium pot, add the tomato sauce and set to medium-high heat.

2. Cook the sauce while stirring constantly until thickened, about 8 to 10 minutes.

3. Remove from the heat and allow to cool for 10 minutes.

4. Using a hand mixer or blender, add the heavy cream and cheese and blend until smooth, about 2 minutes.

5. Add the basil and blend for an additional 5 seconds or until the basil is fully blended and set aside.

To Make the Pizza Puffs

6. Preheat oven to 375°F (190°C).

7. Grease your muffin tin heavily with cooking spray.

8. In a large mixing bowl, add flour, baking powder, garlic powder, Italian seasoning, and salt.

9. Stir in cream and beaten egg.

10. Add in shredded cheeses and diced pepperoni.

11. Let mixture sit covered for 20 minutes.

12. Using an ice-cream scoop or a large spoon, spoon mixture into muffin tins, filling them to the brim.

13. Bake until golden brown, about 20 to 25 minutes. Serve with fondue sauce for dipping.

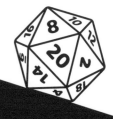

Bard Sliders

I won't hold it against you if you decide to use frozen waffles; however, it's much more satisfying if you make them yourself and then sing about it in extremely lively detail.

KardaChef Type: 1 • *Prep Time: 25 minutes* • *Cook Time: 30 minutes* • *Yield: 6 sandwiches*

1 cup (120 grams) all-purpose flour

⅓ cup (40 grams) cornstarch

1 pinch salt

½ teaspoon (2 grams) baking powder

¼ teaspoon (1 gram) baking soda

2 tablespoons (25 grams) granulated sugar

1 cup (236 milliliters) buttermilk or milk

1 large egg

3 tablespoons (45 milliliters) vegetable oil

8 frozen chicken tenders

4 tablespoons (60 milliliters) maple syrup

2 tablespoons (30 grams) chili paste

To Make the Waffles

1. Combine flour, cornstarch, salt, baking powder, baking soda, and sugar.

2. Mix in the buttermilk and egg, and mix for no longer than 20 seconds.

3. Add the oil to the batter, gently mix once more, and then let rest for 10 minutes.

4. Preheat an 8-inch square waffle iron and grease lightly with cooking spray.

5. Pour about 1½ cups (355 milliliters) of the waffle batter into the preheated waffle iron.

6. Bake until browned and crisp, about 4 minutes.

7. Transfer the waffles to the oven at 200°F (93°C) to keep warm and repeat with the remaining batter.

8. Bake chicken tenders according to directions in the recipe in the Level Up! note (or on the package if using frozen). Aim to cook until crispy.

To Assemble

9. Once the tenders are cooked, mix together the maple syrup and chili paste in a large bowl.

10. Toss the chicken in the mix until fully coated.

11. Quarter each waffle. Place chicken on one quarter of the waffle and top with another quarter to complete the sandwich. Repeat with remaining quarters.

LEVEL UP!

If you are the type of gamer who likes to take on every side quest, you can make your own chicken tenders for extra EXP.

1 tablespoon (14 grams) smoked paprika

1 tablespoon (14 grams) garlic powder

1 tablespoon (14 grams) onion powder

2 large boneless, skinless chicken breasts or 8 tenderloins (about 2 pounds or 907 grams sliced 1 inch thick and 3 inches long)

2 cups (240 grams) all-purpose flour

1 tablespoon (14 grams) salt

1 teaspoon (6 grams) black pepper

2 large eggs, beaten

1¼ cup (60 milliliters) water

4 cups (240 grams) panko breadcrumbs

2 tablespoons (30 milliliters) vegetable or canola oil

1. Preheat oven to 400°F (204°C).

2. In a small bowl, mix paprika, garlic powder, and onion powder.

3. Season the sliced chicken strips with half the seasoning and set aside.

4. Using 3 separate bowls, put the flour in one bowl, the eggs and water into a second shallow dish, and the panko with the oil in a third shallow dish. Toss the panko in the oil.

5. Dip the chicken strips in the flour, then egg, then panko. Press the strips into the panko to ensure the chicken is evenly coated.

6. Add the chicken strips to a large sheet pan that is greased or lined with parchment.

7. Bake for 15 minutes and then carefully flip each piece of chicken over. Continue baking for an additional 10 to 15 minutes or until the chicken is cooked to 165°F (74°C).

8. Once complete, remove from the oven and sprinkle with the salt and pepper.

BABY BLTs (HOLD THE L)

This style of making a BLT is quite unique, but I assure you this plate will be surrounded; you'll need to make extra. The only wrong move you can make is not making enough.

KardaChef Level: Type Null • *Prep Time: 20 minutes* • *Cook Time: 15 minutes* • *Rest Time: 1 hour* • *Yield: 12 bites*

9 strips bacon

2 scallion onions, thinly sliced on a bias

4 tablespoons (60 milliliters) mayonnaise

1 bunch fresh chives, chopped small

1 teaspoon (5 grams) garlic powder

⅓ cup (16 grams) chives

12 large cherry tomatoes

1. Preheat oven to 400°F (204°C).

2. Place bacon on a large sheet pan and be sure each slice isn't touching to ensure it gets crispy.

3. Bake in oven 12 to 15 minutes, or until evenly brown. Once cooled, crumble and set aside.

4. In a large bowl, mix cooled bacon, scallions, mayonnaise, chives, and garlic powder until well blended. Place in the refrigerator while prepping tomatoes.

5. Carefully slice the top (stem side) and bottom of each cherry tomato horizontally. Make sure each tomato stands up on its own like a little cup.

6. Using a melon baller, or a small butter knife, scoop out the inside of each tomato and discard.

7. Take the filling from the refrigerator and place it inside a pastry bag (or sealable plastic bag) and cut the tip to create a small hole.

8. Gently squeeze the bag to fill each cherry tomato to the top with the filling.

9. Chill for an additional hour before serving.

10. Top with additional chives.

Cheesesteak Hand Pies

This is a simple-to-create meat pie without all the mess. The people of Philadelphia do not endorse this, but heroes demand this at their feast. Be sure to let them cool or have a heat-resistant ring close by.

KardaChef Level: Type 2 • Prep Time: 60 minutes
Cook Time: 35 minutes • Rest Time: 5 minutes • Yield: 12 hand pies

One 6- to 8-ounce (170- to 200-gram) rib eye steak

1 whole shallot, thinly sliced

1 whole bell pepper, thinly sliced

½ cup (64 grams) cream cheese

2 tablespoons (30 milliliters) vegetable oil

1 tablespoon (14 grams) salt

1 teaspoon (5 grams) black pepper

2 teaspoons (10 grams) garlic powder

1 tablespoon (15 milliliters) Worcestershire sauce

1 teaspoon (5 milliliters) soy sauce

12 phyllo shells

½ cup (64 grams) shredded mozzarella cheese

1. Place the rib eye steak in the freezer for 1 hour prior to prepping.
2. Place the shallots and bell peppers in a large bowl.
3. In another bowl, stir cream cheese until soft.
4. Remove steak from freezer and shave as thin as possible. Think playing card thin.
5. Take a medium sauté pan and add oil and heat until glossy.
6. Add the shallots and peppers, then cook at a medium-to-low heat until caramelized, about 18 to 20 minutes.
7. Add the steak and season with salt, pepper, garlic powder, Worcestershire sauce, and soy sauce.
8. Cook until the liquid has evaporated from the pan, about 2 minutes.
9. Remove from the heat and add to the bowl of cream cheese; mix until incorporated.
10. Refrigerate while you prepare the shells.
11. Using nonstick cooking spray, grease the muffin tins.
12. Fill each well with a phyllo shell.
13. Fill each tart with the steak filling.
14. Top each with shredded mozzarella.
15. Bake at 375°F (190°C) until cheese is browned, about 12 to 15 minutes.

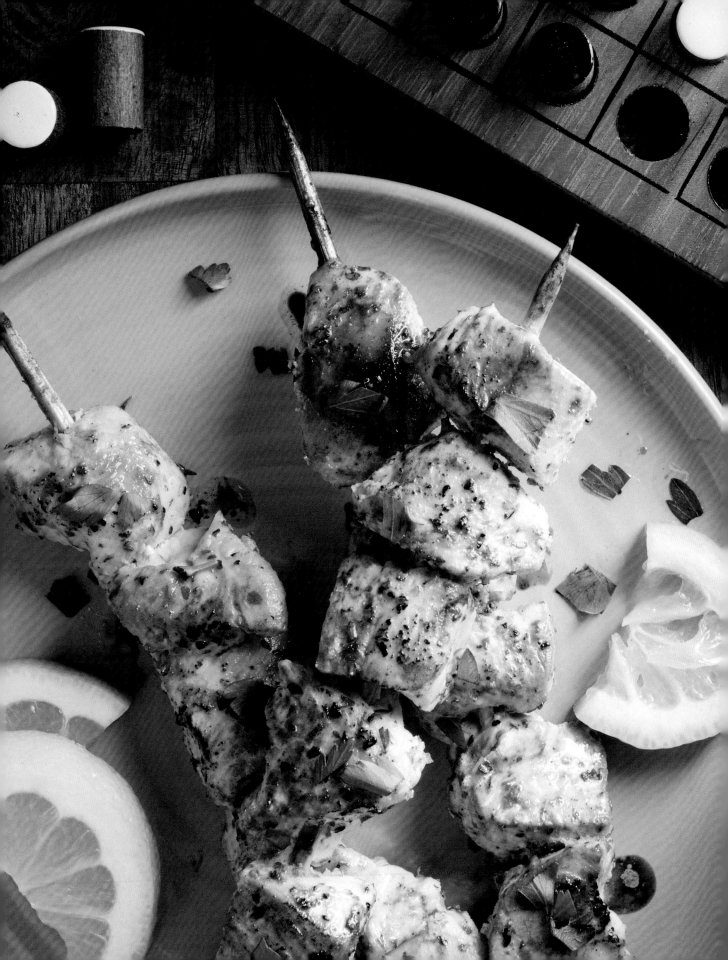

STABBY STABBY STAB

Welcome to the "on a stick" section. Everything tastes better when it's on a stick. My goal here was to provide you with options that normally don't fit with the traditional definition of a kebab. I guarantee most of you haven't had pasta on a stick; I am here to change your life. The best part is, if you're playing a game that occupies both hands, your teammate can easily feed you.

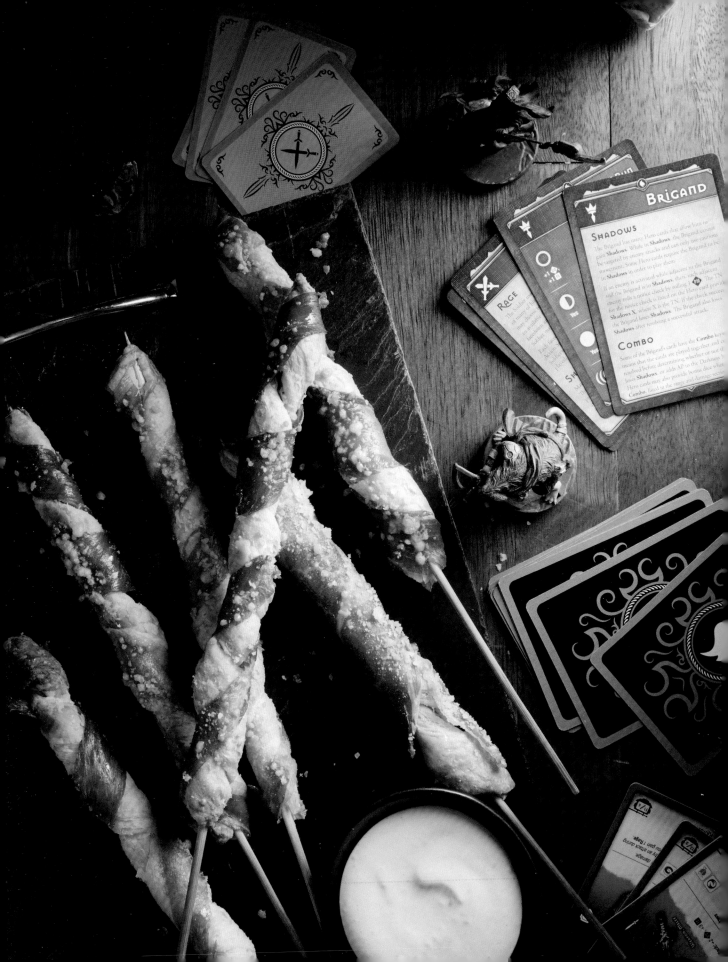

BRIGAND

SHADOWS

The Brigand has many Hero cards that allow him to gain **Shadows**. While in **Shadows**, the Brigand cannot be targeted by enemy attacks and can only use cautious movement. Some Hero cards require the Brigand to be in **Shadows** in order to play them.

If an enemy is activated while adjacent to the Brigand and the Brigand is in **Shadows**, then, each adjacent enemy rolls a notice check by rolling the TN for the notice check is listed on the Hero card **Shadows X**, where X is the TN. If the check succeeds the Brigand also loses **Shadows** after resolving a successful attack.

COMBO

Some of the Brigand's card have the **Combo** keyword means that the cards are played together and are resolved before determining whether or not the **Shadows** or adds AP to the Darkness. Hero cards may also provide bonus dice when **Combo**, listed in the range and damage.

RAGE

The Soldier of many of...

Pass Turn Puffs

Why are there no lawyers who are gnomes? They are unable to pass the bar.
Why are paladins always wearing chainmail? It is holey armor!
Why was the musician kicked out of the tavern? He was bard!
Please feel free to *pass* on these terrible jokes.
…Okay. I'll see myself out.

KardaChef Level: Type 1 • **Prep Time: 1 hour** • **Cook Time: 10 minutes** • **Yield: 10 skewers**

Skewers

2 sheets of puff pastry (you can also substitute with 1 can of thinly sliced canned biscuits)

10 wood skewers

Salt to taste

¼ cup (90 grams) grated Parmesan cheese

6 ounces (170 grams) Prosciutto di Parma

Lemon Aioli

1 cup (250 milliliters) mayonnaise

1 lemon, zested and juiced

1 pinch salt

1. Place puff pastry in the fridge the night before to defrost, or place on a countertop at room temperature for 40 minutes before starting.

2. Preheat oven to 400°F (204°C).

3. Wrap a skewer in a thin layer of the thawed puff pastry or biscuit dough until half the stick is covered and repeat with additional sticks.

4. Season with salt to taste.

5. Bake in the oven for 10 minutes until golden brown.

6. Remove from the oven and roll in grated Parmesan while still warm.

7. Allow the skewers to cool.

8. Wrap each skewer with 2 pieces of prosciutto in a candy cane–like fashion.

9. To make the lemon aioli: In a small bowl, mix ingredients together.

10. Serve with a side of the lemon aioli, or drizzle the aioli over the top.

TORTELLINI SKEWERS

The fun part of this recipe is finding out how much you can get on the stick. I particularly suggest this recipe for games you know are going to run long.

KardaChef Level: Type 1 • *Prep Time: 1½ hours* • *Cook Time: 40 minutes* • *Yield: 10 skewers*

PESTO

½ cup (125 milliliters) extra-virgin olive oil

8 cloves garlic

2 tablespoons (25 grams) salt

2 cups (250 grams) packed fresh baby spinach

½ cup (68 grams) freshly grated Romano or Parmesan cheese

SKEWERS

One 8-ounce (226-gram) bag frozen cheese, meat, or vegetable tortellini

12 ounces (341 grams) fresh cherry tomatoes, halved

12 ounces (341 grams) fresh mozzarella cheese balls

6 ounces (170 grams) sliced pepperoni

½ cup (64 grams) green olives

1 bunch fresh basil leaves

10 wood skewers

Black pepper to taste

TO MAKE THE PESTO

1. In a blender or food processor, first add oil, garlic, and salt, in that order.

2. Pulse blend for 10 seconds.

3. Add spinach and cheese on top of mix and blend again for 15 seconds, or until all spinach is incorporated.

4. Set aside in the refrigerator until ready to use.

TO MAKE THE SKEWERS

5. Bring a pot of salted water to boil.

6. Prepare a bowl of ice-cold water.

7. Add your choice of tortellini to boiling water and cook until al dente.

8. Remove the pasta and "shock" the pasta in cold water.

9. Drizzle the pasta with a touch of oil and coat to prevent sticking.

10. After the pasta is cooled, toss in 2 tablespoons (28 grams) pesto mix and marinate for a minimum of 1 hour, up to 4 days.

11. In a separate bowl, toss tomatoes, mozzarella, olives, and pepperoni with an additional 2 tablespoons (28 grams) of pesto to marinate.

12. Alternating ingredients, thread the tortellini, tomatoes, pepperoni, cheese, olives, and fresh basil onto skewers.

13. Feel free to mix and match your skewers or make them all the same.

14. Place on your serving dish and crack some fresh pepper on top before serving.

BEEF OF BALANCE

Delicately balancing items on top of one another is a game of skill. This dish will allow you to practice both in the kitchen and the living room. Use the marinating time to practice your stacks.

KardaChef Level: Type 2 • Prep Time: 12 to 24 hours
Rest Time: 5 minutes • Cook Time: 25 minutes • Yield: 10 skewers

Marinade

12 cloves garlic

½ cup (125 milliliters) olive oil

2 tablespoons (25 grams) brown sugar

3 tablespoons (35 milliliters) soy sauce

2 tablespoons (25 grams) salt

2 sprigs rosemary, stripped

4 sprigs thyme, stripped

1 small bunch (about 60 grams) parsley, chopped

1 lemon for garnish

Skewers

Two 8-ounce (250-gram) rib eye steaks, sliced lengthwise ¼ inch thick

10 wood skewers

Olive oil for coating

To Make the Marinade

1. Add all ingredients to blender and purée until smooth.

2. Marinate steaks for a minimum 12 hours, up to 48 hours.

To Make the Skewers

3. After marinating, preheat oven to 400°F (204°C).

4. Soak your wood skewers in water for 20 minutes before assembling.

5. Thread each piece of beef on a skewer and keep them close together.

6. Take your roasting pan and coat the base with olive oil.

7. Lay each skewer flat on the base.

8. Roast for 10 minutes initially; then rotate the skewers with a pair of tongs every 5 minutes to brown them evenly, for a total cooking time of 25 minutes.

9. Sprinkle with the chopped parsley and a squeeze of lemon and serve.

Pro Tip

Try this same marinade with tofu.

Prosciutto-Wrapped Veggies

Consider this your lawful good recipe to start the day. No cooking required, and easily one of the most DM-friendly items for your guests.

KardaChef Level: Type Null • *Prep Time: 15 minutes* • *Yield: 15 to 20 spears*

1 bundle thin asparagus

1 whole red bell pepper

1 whole green bell pepper

3 ounces (85 grams) prosciutto, thinly sliced

1. Rinse the vegetables and pat dry; cut into sticks about 5 inches long.

2. Cut each slice of prosciutto in half lengthwise and wrap one half around a bundle of vegetables containing 1 red bell pepper stick, 1 green bell pepper stick, and 1 asparagus stalk.

3. Serve them standing in a container, or seam down on a plate.

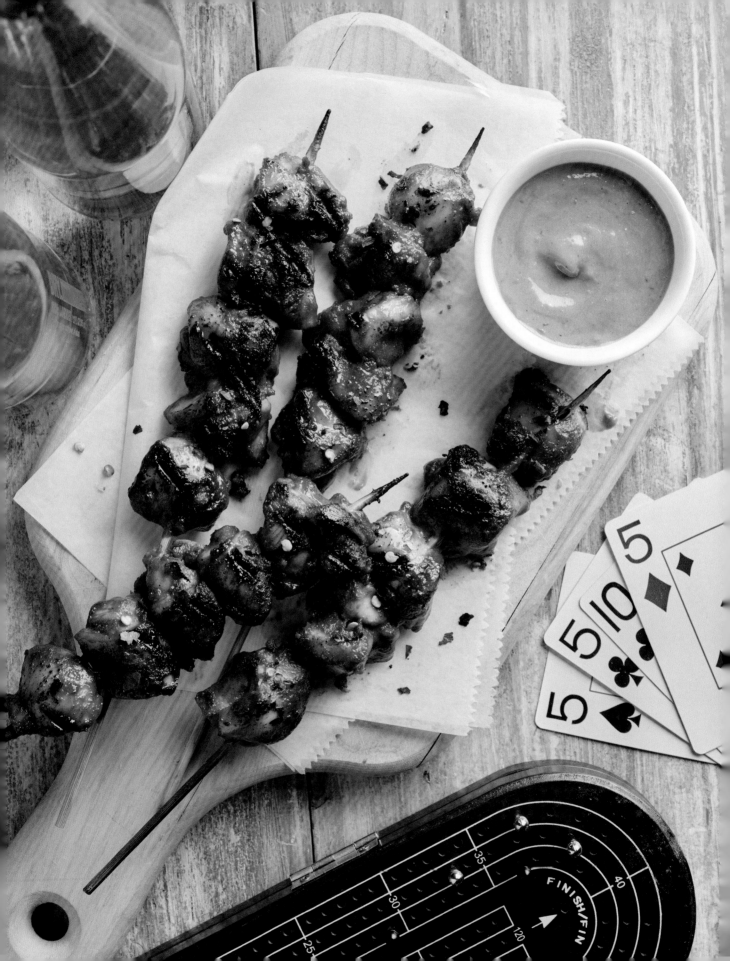

PEANUT SAUCE SKEWERS

Peanut butter is a god-tier food; thus, this take on satay is a great way to use your favorite style of peanut butter. However, smooth is still the best, and Winston would passionately side with me on this one. 1v1 anyone who disagrees.

KardaChef Level: Type 1 · Prep Time: 12 to 24 hours · Rest Time: 5 minutes · Cook Time: 35 minutes · Yield: 20 skewers

20 wood skewers

½ cup (125 milliliters) heavy cream

5 tablespoons (75 milliliters) soy sauce

¼ cup (60 grams) smooth peanut butter

2½ teaspoons (16 grams) yellow curry powder

¼ cup (60 milliliters) lemon juice

2 tablespoons (30 milliliters) chili garlic sauce or sriracha

1 tablespoon (15 grams) brown sugar or 2 tablespoons (25 grams) white sugar

1 tablespoon (15 grams) freshly grated ginger

2 tablespoons (30 milliliters) canola oil

2 pounds (900 grams) boneless, skinless chicken thighs, cut into 1-inch chunks

2 tablespoons (25 grams) salt

1½ teaspoons (8 grams) paprika

3 cloves garlic, minced

1. Soak skewers in water for 1 hour before starting.

2. In a large bowl, mix heavy cream, soy sauce, peanut butter, lemon juice, garlic sauce, brown sugar, ginger, salt, paprika, curry powder, garlic, and oil. Blend by hand, or place in a blender and pulse for 2 minutes until it is the consistency of smooth, thick soup.

3. Set aside ¼ of the mix for the marinade and the rest for finishing sauce.

4. On a clean cutting board, cut chicken thighs and place into the bowl of marinade; be sure to cut them larger to ensure they stay moist when cooking.

5. Thread 5 to 6 pieces of chicken on each skewer. Make sure there is little to no space between each piece.

6. Place completed skewers in a deep roasting pan or a bowl to make sure the skewers are fully submerged.

7. Pour the marinade over them and marinate for 12 to 24 hours.

8. When ready to cook, preheat the oven to 400°F (204°C).

9. Cook the chicken on a cookie tray or roasting pan until it reaches an internal temperature of 165°F (74°C), about 25 to 30 minutes. The marinade should char a bit. You can also finish them on the grill.

10. Take the marinade you reserved and place it in a small pot.

11. Place under a low simmer and reduce until thickened, about 10 to 12 minutes.

12. Drizzle over the top of the chicken, or place in a cup for dipping.

PANCAKE SKEWERS

The perfect way to enjoy your pancakes* for dinner with the easiest way to eat them.

KardaChef Level: Type 0 · *Prep Time: 15 minutes*
Cook Time: 25 minutes · *Yield: 10 skewers*

2 cups (240 grams) all-purpose flour

3 tablespoons (44 grams) granulated sugar

1 teaspoon (15 grams) baking powder

1 teaspoon (15 grams) baking soda

1 pinch salt

1 egg

2 cups (500 milliliters) milk

2 tablespoons (30 milliliters) vegetable or coconut oil

1 teaspoon (6 grams) ground cinnamon

3 tablespoons (43 grams) butter

½ cup (125 milliliters) maple syrup, warmed

10 wood skewers

24 fresh strawberries or whole raspberries

For these pancakes, you're going to be mixing them a bit differently than basic pancakes.

1. Preheat oven to 400°F (204°C).

2. Mix flour, sugar, baking powder, baking soda, and salt in a large bowl.

3. In a separate cup, mix egg, milk, oil, and cinnamon.

4. Add the wet ingredients into the dry and mix with a whisk until smooth.

5. Grease a mini muffin tin (ideally one that holds 12 muffins) with cooking spray.

6. Using a spouted bowl or cup, pour the batter and fill each cup halfway—take care to avoid the sides.

7. Bake for 12 minutes until the tops are firm.

8. While pancakes are baking, prepare the syrup by combining the butter and maple syrup in a small, heatproof bowl. Microwave on high for 20 seconds, then stir.

9. Using a small fork or toothpicks, flip each pancake to have the browned side up.

10. Using a spoon, pour a small amount of the buttered syrup over the top of each "cake."

11. Place in the oven once more for 5 to 6 minutes until the syrup is bubbling.

12. Remove and allow to cool slightly.

13. Take your skewer and thread a piece of fresh fruit first, then 2 to 3 pancakes after. Finish with a piece of strawberry or raspberry.

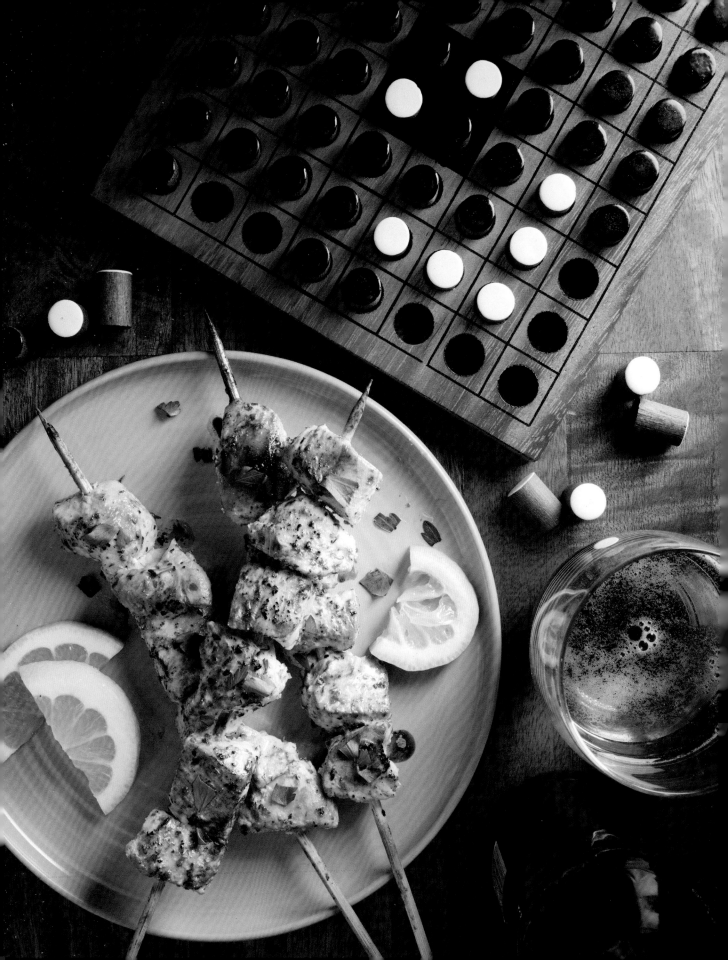

GARLIC LEMON CHICKEN SKEWERS

These will also come out great in your air fryer if you have one! No matter how you cook them, the squeeze of lemon at the end is the perfect finishing touch.

KardaChef Level: Type 2 • *Prep Time: 12 to 48 hours* • *Rest Time: 5 minutes*
Cook Time: 30 minutes • *Yield: 20 skewers*

2 pounds (900 grams) boneless, skinless chicken breasts

1 cup (250 milliliters) plain Greek yogurt

6 lemons, zested and juiced, or ½ cup (125 milliliters) lemon juice

10 cloves garlic, pressed or minced

2 tablespoons (25 grams) dried oregano

2 tablespoons (34 grams) kosher salt

1 teaspoon (2 grams) ground black pepper

20 wood skewers

¼ cup (60 milliliters) olive oil

¼ bunch chopped parsley

1. Dice the chicken into large (about 1-inch) pieces and place in a bowl. Alternatively, you can create strips.

2. In a large bowl, add the yogurt and lemon juice. Whisk until smooth.

3. Add garlic, oregano, salt, and pepper, and mix well.

4. In a resealable plastic bag or a large bowl, place the chicken in the marinade.

5. Marinate for a minimum of 12 hours, up to a maximum of 48 hours.

6. When ready to cook, preheat oven to 400°F (204°C).

7. Soak your wood skewers in water for 20 minutes before prepping the chicken.

8. Thread each piece of chicken on a skewer and keep them close together.

9. Take your roasting pan and coat the base with olive oil.

10. Lay each skewer flat on the base.

11. Roast for 35 minutes; be sure to rotate the skewers with a pair of tongs every 10 minutes to brown them evenly. If using an air fryer, cook at 350°F (177°C) for 10 minutes, flip, and then cook for another 15 minutes, or until the internal temperature is 165°F (74°C).

12. Sprinkle with the chopped parsley, a squeeze of lemon, and the lemon zest, and serve.

MANA SKEWERS

In all variations of this dish, stand by each philosophy and enhance your abilities by using fruit in season. Tie your affinity to your guests and remain faithful to your land. While you should build these with variation in mind, you can also assign one or two affinities to a skewer.

KardaChef Level: Type Null • Prep Time: 15 minutes • Cook Time: 12 minutes • Yield: 19 to 20 skewers

CHILE LIME POWDER

8 ounces (225 grams) pepitas (pumpkin seeds)

1 teaspoon (6 grams) ancho chile powder

1 teaspoon (6 grams) ground paprika

⅛ teaspoon (2 grams) garlic powder

½ teaspoon (4 grams) kosher salt

1 tablespoon (15 milliliters) olive oil

2 teaspoons (50 grams) lime zest

SKEWERS

20 wood skewers

2 cups (400 grams) strawberries

1½ ounces (42 grams) blackberries

1½ ounces (42 grams) blueberries

7 kiwi fruits, peeled and sliced into rounds

½ pineapple, cubed

½ cantaloupe, cubed

TO MAKE THE CHILE LIME POWDER

1. Preheat your oven to 350°F (177°C).

2. Add the hulled pepitas to a large bowl, along with the spices, and drizzle with olive oil and toss.

3. Line a large baking tray with parchment paper. Spread the pepitas out onto the tray and roast until the seeds are lightly toasted, about 12 minutes, stirring halfway through.

4. Remove and allow to cool.

5. Grind the seeds with a spice grinder or blender.

6. Add the lime zest and mix well.

TO MAKE THE SKEWERS

7. Layer each skewer with fruit, starting with a strawberry pushed all the way to the end.

8. Follow that with one blackberry, two blueberries, one kiwi round, one pineapple cube, one cantaloupe cube, and finish with one strawberry.

9. Repeat with each skewer.

10. Arrange on a plate in the form of a rainbow so the strawberries are fanned out at the top.

11. Sprinkle with chile lime powder.

If you prefer, Tajin can be substituted for the chile lime powder.

DRUID SNACKS

If you have anyone who's cranky about eating vegetables, I believe this will bring them over to the green side. The cooking time on these is longer than you may assume for vegetables, so if you pretend you're waiting for your turn in a group of ten, time will go by swiftly.

KardaChef Level: Type 1 • Prep Time: 5 minutes • Cook Time: 20 minutes • Yield: 8 to 10 skewers

3 tablespoons (45 milliliters) vegetable oil, olive oil, or nut oil

20 brussels sprouts, halved lengthwise

3 tablespoons (45 milliliters) sriracha

2 tablespoons (30 milliliters) honey

2 tablespoons (28 grams) butter

½ tablespoon (25 grams) salt

12 wood skewers

1. Use a large frying pan and set to medium-low heat.

2. Line the pan with oil.

3. Carefully place as many brussels sprouts flat side down as you can fit into the pan.

4. Allow the brussels to slowly, heavily darken on one side; this should take about 10 minutes per batch.

5. After they've become tender, remove from the heat and place in a large bowl.

6. Add sriracha, honey, butter, and salt.

7. Toss until the brussels are evenly coated.

8. While warm, thread the brussels onto each skewer.

9. Serve on a long flat plate.

DLC (DIPS LIKE CHIPS)

Crunch the numbers between types of dips with the number of items you can use for dipping, and you'll have an overwhelming series of options at your disposal. This is the section that should inspire you to get creative, mix and match, or even use a D20 to combine a dip and a vessel. Get creative, be strange, or completely ignore me, but above all, make sure you have fun.

BEEFY DEEP

"Do I want a cheeseburger, or do I want dip?" The answer is yes.

KardaChef Level: Type 1 • Prep Time: 1 hour • Cook Time: 25 minutes • Yield: 1 quart (900 grams) of dip

4 tablespoons (60 milliliters) vegetable oil

8 ounces (225 grams) ground beef

1 tablespoon (14 grams) tomato paste

1 tablespoon (15 grams) salt

½ tablespoon (15 grams) garlic powder

1 tablespoon (7 grams) onion powder

¼ cup (60 milliliters) beef or chicken stock

1 teaspoon (4 milliliters) Worcestershire sauce

1 whole red bell pepper, diced about ⅛ inch thick

1 whole red onion, diced about ⅛ inch thick

½ cup (100 grams) sharp cheddar cheese

One 8-ounce (28-gram) block cream cheese, softened or whipped

1 cup (250 milliliters) sour cream

2 tablespoons (25 grams) chopped fresh parsley

1. In a large heavy-bottomed pot, add oil and bring to a high heat.

2. Add ground beef and stir consistently until browned and the liquid has evaporated, about 10 minutes.

3. Drain excess fat and place back in the pot.

4. Add tomato paste, salt, garlic powder, and onion powder and stir until incorporated.

5. Add stock and Worcestershire sauce and simmer until lightly thickened, about 8 minutes.

6. Add peppers and onions, stir for 1 minute, and then remove the pot from the heat.

7. Set the heat to low, add the cheese and cream cheese, and stir slowly until melted.

8. Remove from the heat and fold in the sour cream until fully melted.

9. Place in a shallow bowl and sprinkle the chopped parsley on top.

10. Serve with your choice of dipping bread or chips.

WHITE BEAN DIP

There are about four hundred types of beans in the world. So, if you have a single type of bean, a blender, and the will to live, you can execute this recipe. Your options for beans are incredibly versatile here. Think black beans and cheese, red beans and salsa, lentils and tomato. Find the fun in these. This recipe is experiment friendly.

KARDACHEF LEVEL: TYPE O · PREP TIME: 15 MINUTES · YIELD: 16 OUNCES (450 GRAMS) OF DIP

One 14- to 15.5-ounce (400- to 440-gram) can of beans, such as cannellini, rinsed and drained

4 cloves garlic, minced

Kosher salt to taste

1 teaspoon (6 grams) ground cumin

1 teaspoon (6 grams) chipotle chili powder

4 tablespoons (60 milliliters) fresh lime juice

1 tablespoon (15 milliliters) vegetable oil

¾ cup (175 milliliters) salsa

2 tablespoons (26 grams) crumbled cotija or feta cheese

¼ cup (50 grams) minced fresh cilantro

¼ cup (50 grams) chopped red onion

1. In the bowl of a food processor, add the beans, garlic, kosher salt to taste, cumin, chipotle chili powder, and lime juice.

2. Pulse until combined, then scrape down the sides.

3. Add 1 to 2 tablespoons (15 to 30 milliliters) of water and the oil and blend until the desired consistency and flavor are reached.

4. Spoon the bean dip into a small bowl, create a well with the back of a spoon in the center, and smooth it out. Pour the salsa into the well.

5. Sprinkle with crumbled cotija cheese, and spoon some of the cilantro and onion over the top. Then sprinkle on a little more cotija to serve.

6. Serve with chips or other dipping items.

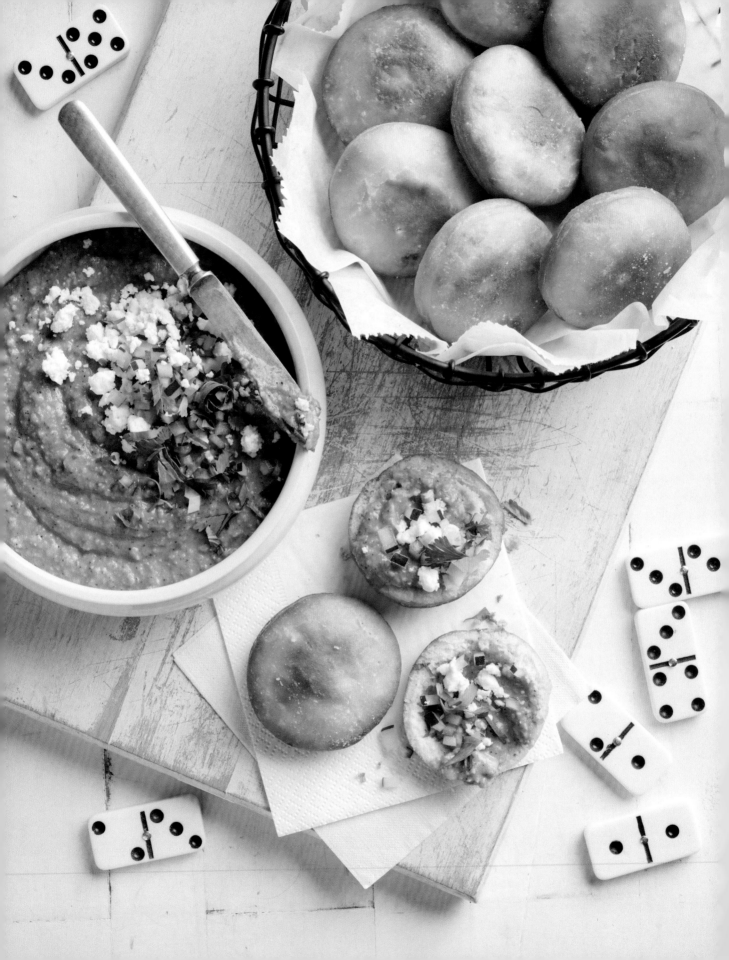

BREAD LOADOUT

There are few snacks more underrated than bread and butter, and there is nothing more important than the feeling of customization. Empowering your guests to mix and match within the meta is exactly how great nights are created. While these are forged to pair with the bread, you can use these butters for any recipe in this book.

FRIED BREAD

Making fresh dough can be a bit intimidating, time-consuming, and even a touch grindy. If you see a bag of dough at the market, feel no fear in snagging it. I give you full permission to completely ignore this recipe and buy fresh dough. The recipe is here just in case, but you'll incur no penalty for taking the shortcut.

KardaChef Level: Type 2 • Prep Time: 60 minutes
Rest Time: 30 minutes • Cook Time: 15 minutes • Yield: 6 servings

½ cup (125 milliliters) warm milk

1 sachet or 2 teaspoons (12 grams) fast-acting yeast

3 tablespoons (43 grams) melted butter

2½ cups (320 grams) all-purpose flour, plus more for dusting

1 teaspoon (6 grams) salt

3 tablespoons (45 milliliters) honey

½ cup (125 milliliters) vegetable oil

1. In a bowl, combine the milk, yeast, melted butter, and honey. Let stand for 10 minutes.

2. In another bowl, combine the flour and salt.

3. Add the yeast mixture and stir with a fork until a soft dough forms.

4. Knead for 1 minute in the bowl while adding flour to prevent sticking.

5. Cover with a warm paper towel. Let the dough rise for about 30 minutes in a warm place, away from drafts (in the microwave oven, for example).

6. On a floured surface, roll out the dough in two large circles.

7. Cut or pull off balls of dough that are about the size of a silver dollar (around 40 millimeters) and flatten each one. Feel free to use a rolling pin to reach your ideal size.

8. In a cast-iron skillet or heavy-bottomed pan, heat the oil.

9. Cook each piece of dough over medium heat until golden, about 3 minutes on each side.

10. Rest each bread on a paper towel.

11. Serve with your favorite butters.

CHIPOTLE LIME BUTTER

If you're part of the percentage of people who think cilantro tastes like soap, please feel free to replace it with parsley.

KardaChef Level: Type Null • Prep Time: 15 minutes
Rest Time: 2 hours • Yield: 1 cup (226 grams) of butter

2 sticks (226 grams) unsalted butter, at room temperature

2 limes, zested and juiced

½ teaspoon (4 grams) salt

2 tablespoons (28 grams) minced garlic

1 tablespoon (14 grams) adobo spice

1 tablespoon (14 grams) paprika

½ teaspoon (4 grams) black pepper

3 tablespoons (1 gram) fresh cilantro, minced

1. Combine all ingredients in a bowl and mix until well combined; the butter should be smooth and spreadable.

2. Place on a piece of plastic wrap and roll into a log. Twist ends to seal well.

3. Refrigerate at least 2 hours. You can keep this for 2 weeks in the refrigerator or 6 months in the freezer.

4. Unwrap and serve with bread.

BACON BOURBON BUTTER

The amount of bacon is purely a suggestion. If you opt to add three times as much or more bacon, I won't blame you.

KardaChef Level: Type Null
Prep Time: 15 minutes • Rest Time: 2 hours
Yield: 1 cup (226 grams) of butter

12 slices bacon

2 sticks (226 grams) unsalted butter, at room temperature

1 tablespoon (15 milliliters) bourbon

2 tablespoons (25 grams) chopped shallots

1 teaspoon (10 grams) brown sugar

1. Cook bacon until crispy, then cool.

2. Chop the bacon into small pieces and set aside.

3. Combine all ingredients in a bowl and mix until well combined; the butter should be smooth and spreadable.

4. Place on a piece of plastic wrap and roll into a log. Twist ends to seal well.

5. Refrigerate at least 2 hours.

6. Unwrap and serve with bread.

MERCHANTS MAPLE BUTTER

Do you feel no shame making breakfast for dinner? Is it 2 a.m. and you're still up saying "one more level"? Are you starving and ready to eat bread like a gremlin over the sink? Then yes, this butter is a perfect pairing to that not-at-all-specific situation. After you finish this recipe, turn back a few pages and put this butter on the pancakes. Trust me.

KardaChef Level: Type Null • Prep Time: 5 minutes • Rest Time: 2 hours • Yield: 1 cup (226 grams) of butter

2 sticks (226 grams) unsalted butter, at room temperature

3 tablespoons (45 milliliters) maple syrup

2 tablespoons (28 grams) ground cinnamon

½ teaspoon (2 milliliters) vanilla extract

1. Combine all ingredients in a bowl and mix until well combined; the butter should be smooth and spreadable.

2. Place on a piece of plastic wrap and roll into a log. Twist the ends to seal well.

3. Refrigerate at least 2 hours. You can keep this for 2 weeks in the refrigerator or 6 months in the freezer.

4. Unwrap and serve with bread.

TACTICAL CHEESE SPREAD

The "Noob Toob" of dips and the most OP loadout when short on time. Make sure you have some solid chip or bread attachments and you're ready to drop anywhere.

KardaChef Level: Type 2 • Prep Time: 15 minutes • Yield: 1½ cups (340 grams) of spread

8 ounces (226 grams) cream cheese

4 tablespoons (57 grams) unsalted butter, at room temperature

1 tablespoon (15 grams) Dijon mustard

1 tablespoon (7.5 grams) capers

3 tablespoons (50 grams) minced white onion

2 stalks scallions, chopped on a bias

1 tablespoon (12 grams) paprika

1 teaspoon (6 grams) salt

1 teaspoon (6 grams) white pepper

1. Use an electric mixer to beat cream cheese and softened butter together until creamy.

2. Using a rubber spatula, gently mix in the remainder of the ingredients.

3. Serve immediately, or you can store this in the refrigerator for up to 7 days.

AGGRO APPLE DIP

Don't let the name fool you; this dip is in no way healthy at all. Nevertheless, this is what I would call a build-friendly recipe. Pair this with savory chips, bread, or even apple slices to be extra redundant! The spices should apply a bit of hostility to this dish.

KardaChef Level: Type 1 · Prep Time: 15 minutes · Cook Time: 15 minutes
Yield: 1 pint (460 grams) of dip, 1 quart (500 grams) of pita chips

Pita Chips

3 slices pita bread

1 tablespoon (15 grams) granulated sugar

1 teaspoon (6 grams) ground cinnamon

¼ cup (60 milliliters) vegetable oil

Dip

⅓ cup (70 grams) brown sugar

2 tablespoons (30 milliliters) honey

2 teaspoons (12 grams) ground cinnamon, plus more for garnish

1 teaspoon (6 grams) nutmeg

1 tablespoon (15 milliliters) apple cider vinegar

½ cup (60 milliliters) apple juice

3 large apples, chopped into small cubes

1 cinnamon stick

3 tablespoons (23 grams) cornstarch

2 tablespoons (30 milliliters) water

1½ cups (368 grams) whole fat yogurt

To Make the Pita Chips

1. Preheat oven to 400°F (204°C).

2. Slice the pita bread into triangle wedges. In a small bowl, combine the sugar and cinnamon and set aside.

3. Using a large cookie tray, drizzle oil on the bottom of the tray.

4. Add the pita chips, being careful to only have a single layer so they can crisp up.

5. Drizzle oil on top of the chips and mix by hand until lightly coated.

6. Bake for 10 to 15 minutes until crispy.

7. Remove from the oven and immediately sprinkle with cinnamon and sugar mix.

To Make the Dip

8. In a medium saucepan, combine the brown sugar, honey, ground cinnamon, nutmeg, apple cider vinegar, and apple juice.

9. Stir in the apples and cinnamon stick.

10. Heat the apple mixture over medium heat until it comes to a boil. Reduce the heat to low and lightly simmer until apples are tender, about 12 minutes.

11. Using a small cup, mix the cornstarch with the water. Mix until it is blended and no cornstarch remains at the bottom.

12. Add the cornstarch slurry and stir. Cook on low, stirring constantly, until thickened, about 3 minutes.

13. Pour the mix into a bowl, remove the cinnamon stick, and place in the fridge to cool. (You are free to serve it like this.)

14. After cooled, gently fold in yogurt until mixed.

15. Sprinkle with cinnamon before serving.

OWLBEAR DIP

The Owlbear dip attacks from two directions—tangy ranch and sweet honey flavors. While this dip is basic, there are lots of subvariants of this dip served in Faerûn. Owlbears are not nice, but this dip is.

KardaChef Level: Type 1 • Prep Time: 20 minutes
Cook Time: 25 to 30 minutes • Yield: 4 cups (1000 grams)

2 cups (270 grams) cooked chicken, shredded

One 8-ounce (227-gram) block cream cheese, softened or whipped

½ teaspoon (3 grams) onion powder

16 ounces (490 grams) sour cream

1 cup (225 grams) bacon, chopped small, plus more for garnish

One 1-ounce (28-gram) package dry ranch seasoning

1½ cups (192 grams) shredded white cheddar jack cheese, divided

2 tablespoons (30 milliliters) honey

2 green onions, diced, for garnish

1. Preheat oven to 400°F (204°C).

2. Spray a 2-quart baking dish with nonstick cooking spray and set aside.

3. In a large bowl, combine the cooked shredded chicken, cream cheese, onion powder, sour cream, bacon, ranch seasoning, and 1 cup (128 grams) shredded cheese.

4. Transfer mixture to prepared baking dish.

5. Top with the remaining ½ cup (64 grams) shredded cheese.

6. Bake uncovered for 25 to 30 minutes, until hot and bubbly.

7. Remove from the oven and drizzle honey on top while still warm.

8. Top with diced green onions and more chopped bacon.

9. Serve with firm chips or crusty bread, or even celery (but why would you choose celery, you monster!?).

WILD CARD DIP

The wild card is a high-risk and high-reward moment. That tense moment could cost you more than you bargain for or send your opponents into a rage. It's all smiles until someone is holding four of these.

KardaChef Level: Type 2 • Prep Time: 15 minutes • Yield: 1½ cups (360 grams)

One 8-ounce (227-gram) package cream chese, softened

½ cup (118 milliliters) heavy whipping cream

1 cup (198 grams) marshmallow cream (fluff)

2 cups (450 grams) powdered sugar

1 teaspoon (5 milliliters) vanilla extract

4 food-safe gel colors (red, blue, green, and yellow)

2 tablespoons (28 grams) confetti sprinkles

3 ounces (85 grams) graham crackers or sugar wafer cookies for dipping

1. In a bowl, combine cream cheese, heavy cream, marshmallow cream, sugar, and vanilla. Blend with an electric mixer until smooth, about 3 minutes.

2. Divide mixture into 4 equal parts in 4 separate bowls.

3. Add 3 small drops of gel color to each bowl. Mix until each bowl is the appropriate color shade. You may adjust this to your tastes.

4. In a clean serving bowl, add 1 spoonful of each of your colored mixtures in each corner, alternating until your bowl is full. You are aiming to make four quarters clockwise.

5. Take a toothpick or skewer and lightly smooth the seams of the colors until all four have a unified look.

6. Add sprinkles.

7. Serve with graham crackers and/or sugar wafer cookies for dipping.

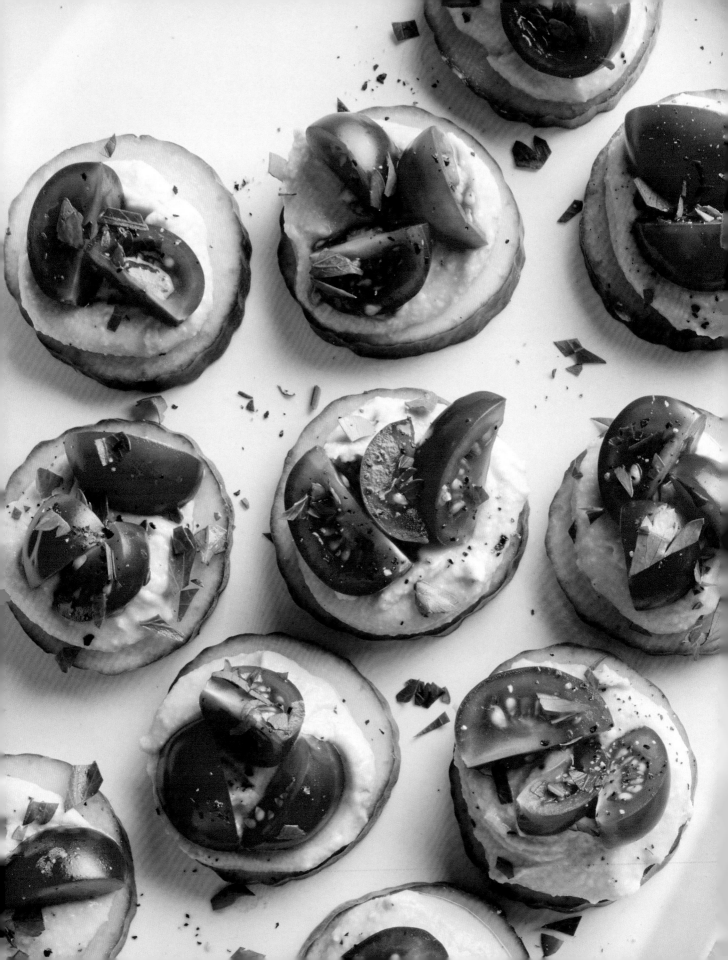

TURN ORDER TARTS

This section is dedicated to one-bite items. Tarts, cups, and hors d'oeuvre recipes are easy for guests to pop in their mouths and keep the game going. You can also make this part of the game if you prefer. For example, a player can only have a bite if they score, after they roll, or simultaneously with the group.

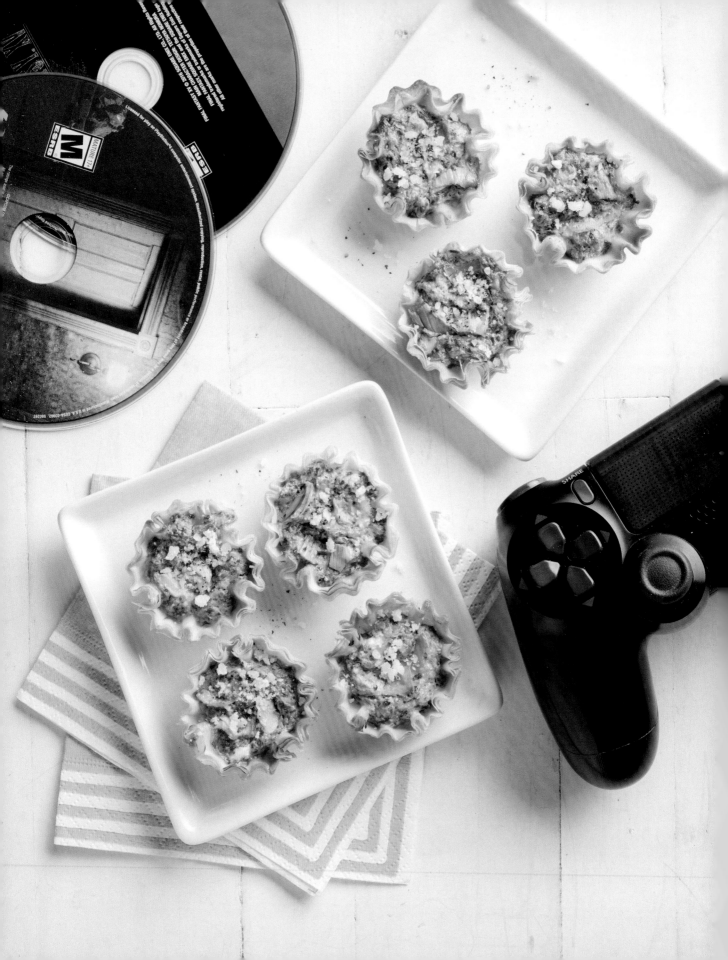

SPINACH ARTICHOKE HEARTS OF DARKNESS

My goal here was to take one of the traditionally messier dips and make it easy to enjoy. However, I'm not joking when I say let them cool, or you will hear guests scream for the wrong reasons, and not even the Pools of Aggonar will help.

KardaChef Level: Type 1 • *Prep Time: 30 minutes* • *Rest Time: 10 minutes*
Cook Time: 15 to 20 minutes • *Yield: 28 to 30 shells*

One 9-ounce (38-gram) bag baby spinach, chopped small

One 12-ounce (340-gram) jar marinated artichoke hearts, drained and chopped

One 8-ounce (227-gram) block cream cheese, softened or whipped

½ cup (125 milliliters) mayonnaise

¼ cup (60 milliliters) sour cream

6 cloves garlic, minced

½ cup (100 grams) grated Parmesan cheese

30 phyllo shells (2 packages)

1. Preheat oven to 375°F (190°C).

2. Line baking sheet with parchment paper or aluminum foil. Set aside.

3. Add all ingredients except for the phyllo shells to bowl of food processor fitted with steel blade.

4. Pulse process 7 or 8 times, or until mixture is well combined and artichoke hearts are finely chopped. If you don't have a food processor, chop the artichokes and spinach by hand, then mix with a spoon or rubber spatula.

5. Transfer mixture to piping bag fitted with large star tip.

6. Pipe mixture into shells and place on prepared baking sheet.

7. Bake in preheated oven for 15 minutes, or until the top of each tart is bubbling.

8. Let cool for a bit before serving.

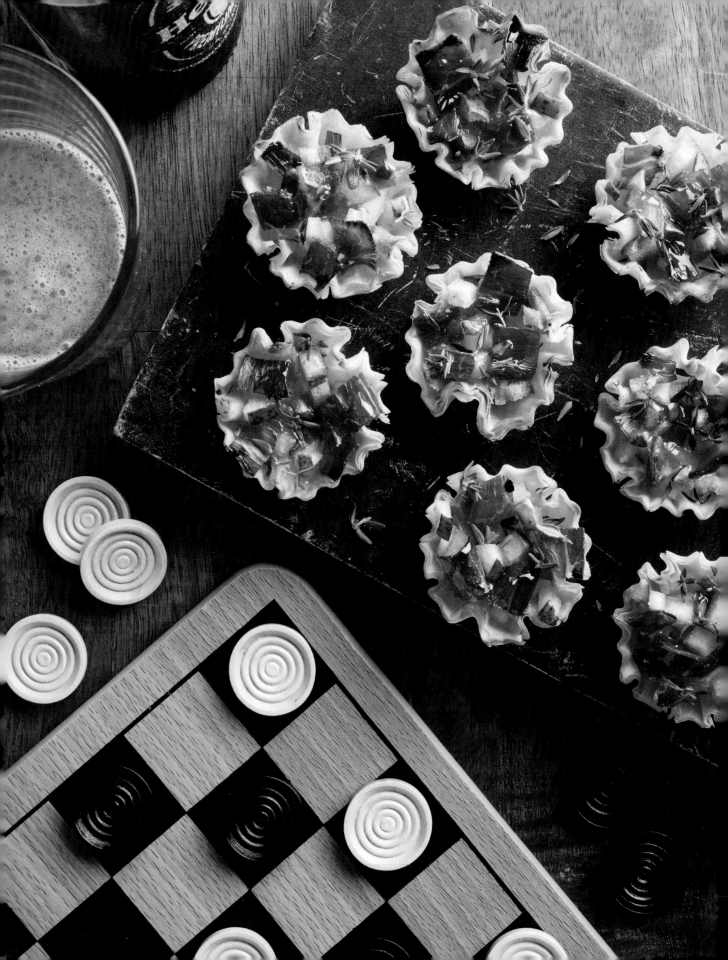

PVP Tarts

The fundamentals of the old school and the bold experimentation of the new guard are what makes the evolution of games exciting. This Pear, Vinegar, and Prosciutto Tart is a spin on a familiar recipe, but with a cleaner execution. Any cheese lover will appreciate less mess and a unique take on this classic pairing.

KardaChef Level: Type 1 • Prep Time: 30 minutes • Rest Time: 10 minutes
Cook Time: 15 to 20 minutes • Yield: 24 shells

Balsamic Reduction

2 cups (473 milliliters) balsamic vinegar

½ cup (100 grams) brown sugar

Tarts

24 mini phyllo tart shells

¼ pound (110 grams) ripe Brie cheese, cut into 24 small chunks, about ¼ inch each

1 ripe pear, diced small, about ⅛ inch each; place in a bowl of water

6 ounces (170 grams) prosciutto, cut into large cubes

2 tablespoons (25 milliliters) honey

2 sprigs fresh thyme, chopped

To Make the Balsamic Reduction

1. In a medium pot, add the sugar and balsamic and place over medium heat.

2. Stir occasionally until thickened, about 10 minutes.

3. Cool for at least 15 minutes and set aside.

To Make the Tarts

4. Preheat oven to 400°F (204°C). Line a cookie sheet with parchment paper or foil.

5. Arrange tart shells onto prepared pan.

6. Put a piece of Brie cheese into each shell.

7. Sprinkle with diced pear and a few cubes of prosciutto.

8. Drizzle each tart with honey.

9. Top each tart with a bit of thyme.

10. Bake in oven until cheese is melted and tarts are golden, 12 to 15 minutes.

11. Drizzle the balsamic reduction over the top of each tart and serve.

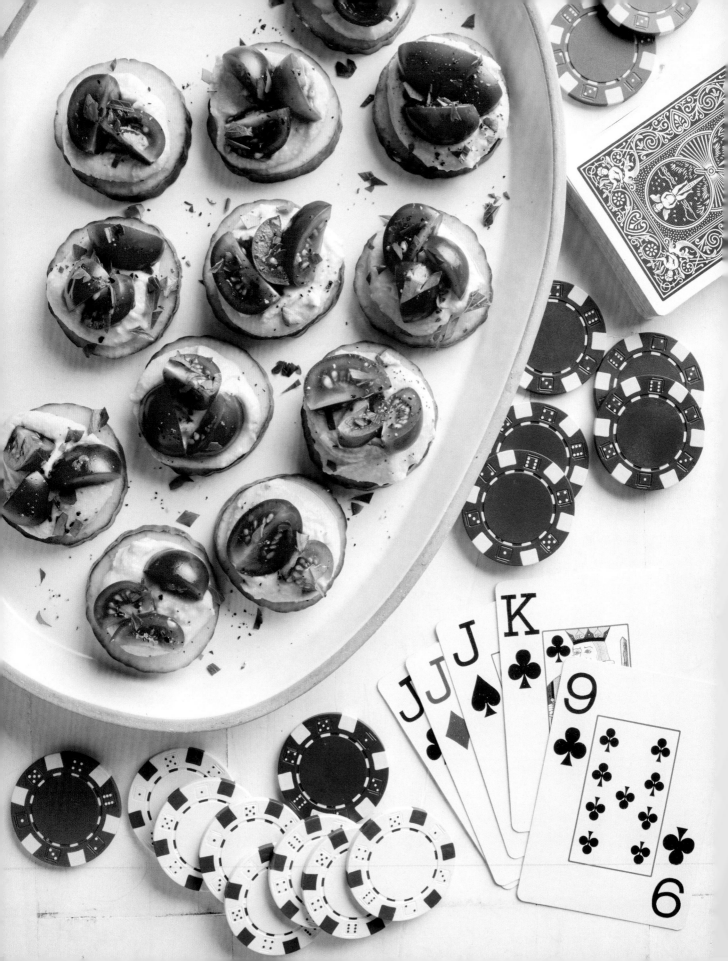

Cucumber Hummus Tarts

If you read this and said, "I'm never going to make this," you aren't eating enough vegetables.

KardaChef Level: Type 1 • Prep Time: 15 minutes • Rest Time: 30 minutes • Yield: 28 to 30 tarts

Hummus

¼ cup (60 milliliters) extra-virgin olive oil

4 cloves garlic

Two 15-ounce (425-gram) cans chickpeas, drained

⅓ cup (80 milliliters) lemon juice, freshly squeezed

1 teaspoon (6 grams) kosher salt

Cucumber Marinade

1 cup (250 milliliters) lemon juice

½ cup (125 milliliters) rice wine vinegar

1 tablespoon (15 grams) sugar

1 large English cucumber, sliced about ⅓ inch thick

Assembly

1½ cups (375 grams) hummus

¾ cup (150 grams) cherry tomatoes, quartered

Black pepper to taste

¼ cup (50 grams) chopped fresh parsley

To Make the Hummus

1. Add all ingredients to a bowl and use a hand mixer or food processor to blend, but keep the mix on the thicker side.

2. Season with black pepper to taste.

3. Cool to prepare for the cucumber.

To Make the Cucumber Marinade

4. Mix the lemon juice, vinegar, and sugar together and sprinkle over the cucumbers.

5. Marinate for 30 minutes before assembling.

To Assemble

6. Using a melon baller or spoon, create a dip in the center of the cucumber, being careful to not cut all the way through.

7. Using a spoon or pastry bag, place a dollop of hummus in the dip you just created.

8. Top the hummus with a few cherry tomatoes.

9. Crack a touch of black pepper over the top of each tomato.

10. Top each tart with parsley and serve.

Pro Tip

Aim for thicker consistency to make it easy to serve the dish. If you want a shortcut, you can always go for about 10 ounces (280 grams) of store-bought hummus.

FRENCH TARTS FTW

Let's be honest, soup is not the first item any adventurer or player reaches for. Serving soup has really fallen out of style, and over time we have lost the culture of soup in favor of speed and in lieu of patience. This recipe is here to right this wrong. Enjoy all the bold flavors of this classic soup with half the steps (and none of the mess).

KARDACHEF LEVEL: TYPE 2 • PREP TIME: 1 HOUR • COOK TIME: 1 TO 1½ HOURS • YIELD: 18 TARTS

2 tablespoons (28 grams) butter

2 tablespoons (30 milliliters) canola oil

4 large white onions, thinly sliced

3 tablespoons (35 grams) brown sugar

3 teaspoons (15 milliliters) Worcestershire sauce

1 teaspoon (6 grams) salt

18 ready-to-bake pastry or phyllo shells

½ cup (100 grams) Swiss or Gruyère cheese, chopped small

1. Preheat oven to 375°F (190°C).

2. Over medium heat, heat a large skillet before placing in butter and oil.

3. Add onion, sugar, Worcestershire sauce, and salt.

4. Cook uncovered over medium heat, moving the onions around, until onions begin to get dark brown, about 30 to 45 minutes.

5. Line a baking sheet with parchment paper or aluminum foil. Place the tarts ½ inch apart. Set aside.

6. Add caramelized onion mix to each tart.

7. Top each with chopped Swiss cheese.

8. Bake in preheated oven for 15 minutes, or until the top of each tart is bubbling.

9. Let cool for 5 minutes before serving.

PUFF PASTRY AND PROSCIUTTO

Let's say you only have a few precious moments to grab a fulfilling bite before you're required to get back into the game. This adorable little purse of puffed perfection popped into your portal is just right.

KardaChef Level: Type 2 • Prep Time: 1 hour • Cook Time: 18 to 25 minutes • Yield: 12 tarts

2 sheets frozen puff pastry, thawed

1 tablespoon (15 milliliters) olive oil

1 tablespoon (15 grams) lemon pepper

1 bunch pencil-thin asparagus, ends trimmed

12 slices or 6 ounces (170 grams) prosciutto

8 ounces (100 grams) white cheddar, shredded

1 egg, beaten

1. Preheat oven to 425°F (218°C).

2. Line two sheet pans with parchment paper.

3. On a lightly floured surface, roll the puff pastry out to a large rectangle. Cut the pastry into 12 squares and lay them ½ inch (1.3 centimeters) apart on the sheet pans.

4. In a bowl, rub the oil and lemon pepper on the asparagus.

5. To make the bundles, place a slice of prosciutto on top of the pastry square.

6. Follow with 1 to 2 stalks of asparagus (depending on size) and sprinkle with 1 to 2 tablespoons (14 to 28 grams) of cheese.

7. Gently lift two opposite corners of the puff pastry squares and wrap them around the asparagus and press to seal.

8. Brush puff pastry with egg wash.

9. Sprinkle additional cheese on top and place in the oven.

10. Bake until puff pastry is golden and puffed, about 10 to 12 minutes.

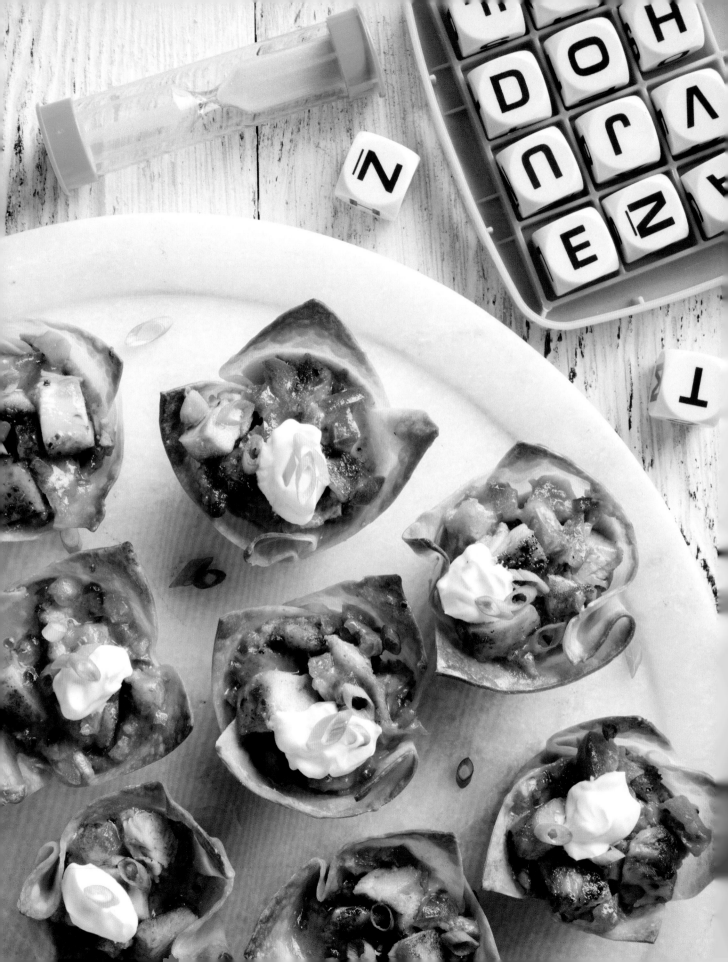

Wonton Nacho Cups

This recipe came about from badly making wontons and having to make the best out of a bad situation. However, there is no bad time for nachos. The use of wontons allows this to be a little lighter and leaves more room to enjoy the goodies on a plate of nachos in one easy bite.

KardaChef Level: Type 2 • Prep Time: 1 hour • Cook Time: 45 to 50 minutes • Yield: 12 tarts

Chicken

2 tablespoons (25 grams) paprika

1 tablespoon (15 grams) salt

2 tablespoons (25 grams) lemon pepper

4 boneless, skinless chicken thighs, about 12 ounces (448 grams)

Wontons

12 wonton wrappers

1 cup (200 grams) diced fresh tomato

1 jalapeño, diced small

1 cup (200 grams) shredded cheddar cheese

8 ounces (227 grams) refried beans

Sour cream for garnish

1 scallion, thinly sliced

To Make the Chicken

1. Preheat the oven to 400°F (204°C). In a small bowl, combine the paprika, salt, and lemon pepper. Season the thighs with the spice mix and place on a roasting pan or cookie tray. Roast in the oven for 30 minutes or until internal temperature of the chicken is 165° F (74° C).

2. Remove the chicken from the oven and set aside to allow it to cool.

3. When the chicken is cool, dice it small enough to make sure there is a little bit in every bite.

To Make the Wontons

4. Preheat the oven to 350°F (177°C).

5. Prepare a muffin tin and grease lightly with cooking spray.

6. Press wonton wrappers into the pan to make a cup shape. Bake for 5 minutes or until lightly golden.

7. While baking, mix tomato, jalapeño, chicken, and shredded cheese in a medium bowl.

8. Remove muffin tin from oven and place a layer of beans at the base of each cup.

9. Top the beans with your chicken mixture until nearly full; leave enough space for garnish.

10. Bake the filled wontons in the oven until the cheese is nicely melted and bubbling, about 15 minutes.

11. Remove from the oven and allow them to cool for a few minutes before removing from the muffin tin.

12. Using a large spoon, place each wonton cup on a plate.

13. Top each cup with a dollop of sour cream and garnish with scallions and serve.

Bot Lane Biscuits

KardaChef Level: Type 2 • Prep Time: 40 minutes • Cook Time: 20 minutes • Yield: 14 sandwiches

10-count, 12-ounce (340-gram) can flaky layered biscuits

8 ounces (225 grams) or about 4 slices thinly sliced deli ham

8 ounces (225 grams) or about 4 slices cheddar or American cheese

2 tablespoons (5 grams) chopped fresh thyme

2 cups (473 milliliters) vegetable oil

Salt and black pepper to taste

1. Pull apart each biscuit, creating 2 equal rounds per biscuit.

2. Flatten the biscuit rounds with your fingers or use a rolling pin to gently flatten.

3. Place 1 ham and 1 cheese slice into the center of ½ of the rounds. Sprinkle each with ⅛ teaspoon (0.3 grams) of thyme and place another biscuit round on top.

4. Using your fingertips, press the outer rim of the dough to seal in the filling.

5. Set aside and prepare the oil in a heavy-bottomed sauté pan or cast-iron pan.

6. At a temperature of 350°F (177°C), fry each sandwich until golden brown, about 12 minutes. Place on a towel to drain grease.

7. Sprinkle with salt and pepper to taste, then serve.

SIDE QUESTS

A side quest is created to take you off the beaten path. In these moments, you don't just learn more about your world, but a bit more about yourself. The recipes here should reflect the nature of the best types of side quests: short, simple, and impactful. Use this section to create the easiest snacks for your guests while making your main campaign a little more memorable.

POPCORN VARIANTS

The smell of popcorn is tantamount to the experience of entertainment. Each of these popcorn recipes represents crowd-pleasing flavors. The most important thing to remember is that you have full permission to start with microwave popcorn if you want. I do not suggest you clap in between bites, but that could end up being quite a fun game as well.

BASIC POPCORN

KardaChef Level: Type Null • Prep Time: 5 minutes • Cook Time: 6 to 8 minutes
Yield: 5 cups (40 grams) of popcorn

3 tablespoons (45 milliliters) canola oil

3 tablespoons (45 grams) popcorn kernels

1 tablespoon (15 grams) salt

1. In a large, heavy-bottomed saucepan, heat the oil over medium heat. Test the temperature by tossing one kernel into the pot and wait for it to pop. Once it does, add the remaining kernels. Keep the burner at medium heat.

2. Cover the pot and wait for the kernels to pop, about 8 minutes.

3. Once the first few kernels pop, begin to shake the pot to distribute the kernels evenly. Movement is the key here, to prevent burning.

4. Put the pot back onto the burner and continue cooking the popcorn until you hear little to no additional popping, about 2 minutes.

5. Remove from heat and pour into a large bowl to season immediately with salt.

LEMON PARM POPCORN

KardaChef Level: Type 1 • Prep Time: 5 minutes • Cook Time: 6 to 8 minutes
Yield: 5 cups (40 grams) of popcorn

4 tablespoons (57 grams) butter

2 tablespoons (25 grams) lemon pepper

5 cups (40 grams) Basic Popcorn (page 76)

1 teaspoon (6 grams) salt

¼ cup (50 grams) grated Parmesan cheese

1. In a small pot, add butter.

2. Set to low heat until melted.

3. Add lemon pepper.

4. After making your popcorn, pour the butter over it and coat evenly.

5. Finish with salt and Parmesan cheese.

Garlic Rosemary Popcorn

KardaChef Level: Type 1 • *Prep Time: 5 minutes* • *Cook Time: 6 to 8 minutes*
Yield: 5 cups (40 grams) of popcorn

¼ cup (60 milliliters) olive oil

1 tablespoon (15 grams) chopped rosemary

3 cloves garlic, roughly chopped

5 cups (40 grams) Basic Popcorn (page 76)

1 tablespoon (15 grams) garlic powder

1 teaspoon (6 grams) salt

1. In a small pot, add the oil, rosemary, and garlic.

2. Set to low heat until the oil is warmed, then shut it off to steep, about 10 minutes.

3. Strain the oil and use this as your oil for popping the popcorn. Follow the Basic Popcorn Recipe.

4. After making your popcorn, season with garlic powder and salt. If using premade microwave popcorn, drizzle the rosemary oil over the top and season with the garlic powder and salt.

Pad Thai Popcorn

KardaChef Level: Type 1 • *Prep Time: 5 minutes* • *Cook Time: 6 to 8 minutes*
Yield: 5 cups (40 grams) of popcorn

3 tablespoons (43 grams) unsalted butter, melted

1 tablespoon (15 grams) brown sugar

1 teaspoon (6 grams) salt

2 tablespoons (30 milliliters) sriracha

5 cups (40 grams) Basic Popcorn (page 76)

1 tablespoon (6 grams) lime zest

1. In a small pot, add butter.

2. Set to low heat until melted.

3. Add brown sugar, salt, and sriracha. Stir gently until the brown sugar dissolves.

4. After making your popcorn, pour the butter over it and coat evenly.

5. Finish with lime zest.

Canteen Kettle Corn

If you've made it to this recipe, then I assume you've leveled up enough to tackle this challenge. This is a Chef's Choice item in the canteen and is guaranteed to give you a spike in stamina, defense, and resistance.

KardaChef Level: Type 1 • Prep Time: 5 minutes
Cook Time: 6 to 8 minutes • Yield: 5 cups (40 grams) of popcorn

Seasoning

¼ cup (50 grams) brown sugar

1 tablespoon (15 grams) salt

2 teaspoons (12 grams) black pepper

2 teaspoons (12 grams) paprika

2 teaspoons (12 grams) garlic powder

2 teaspoons (12 grams) onion powder

½ teaspoon (3 grams) cayenne pepper

Kettle Corn

2 tablespoons (30 milliliters) vegetable oil

¼ cup (32 grams) popcorn kernels

2 tablespoons (25 grams) granulated sugar

To Make the Seasoning

1. Combine all ingredients in a medium bowl. Set aside.

To Make the Kettle Corn

2. In a large, heavy-bottomed saucepan, heat the oil over medium heat.

3. Test the temperature by tossing one kernel into the pot and waiting for it to pop. Once it does, add your kernels and sugar, then cover the pot and wait for the kernels to pop, about 10 minutes.

4. Once the first few kernels pop, begin to shake the pot to distribute the kernels evenly. Lots of movement is the key here, and you want to avoid burning the sugar.

5. Put the pot back onto the burner and continue cooking the popcorn until you hear little to no additional popping, about 5 minutes.

6. Remove from the heat and pour into a large bowl.

7. Season immediately and serve.

Pro Tip

Smoked paprika works well here.

THE THIRD AGE TENDERS

KardaChef Level: Type 2 • Prep Time: 1 hour • Cook Time: 30 to 40 minutes • Yield: 8 tenders

SAUCE

2 tablespoons (30 milliliters) chili paste

3 tablespoons (44 milliliters) ranch dressing

Juice from 2 lemons, or ⅓ cup (78 milliliters) lemon juice

Zest from 2 lemons

1 teaspoon (6 grams) adobo spice

1 tablespoon (14 grams) butter, cold

TENDERS

1 tablespoon (14 grams) smoked paprika

1 tablespoon (14 grams) garlic powder

1 tablespoon (14 grams) onion powder

2 large boneless, skinless chicken breasts or 8 tenderloins, about 2 pounds (907 grams)

2 cups (400 grams) all-purpose flour

2 large eggs, beaten

1 cup (60 milliliters) water

1 tablespoon (14 grams) salt

1 teaspoon (6 grams) black pepper

4 cups (800 grams) panko breadcrumbs

2 tablespoons (30 milliliters) vegetable oil

TO MAKE THE SAUCE

1. Take a small bowl and mix all ingredients except for the butter until incorporated, then set aside.

2. The butter will be added when ready to mix with the tenders.

TO MAKE THE TENDERS

3. Preheat oven to 400°F (204°C).

4. In a small bowl, mix paprika, garlic powder, and onion powder.

5. Season the chicken strips (or tenderloins) with the seasoning, then set aside.

6. Using 3 separate bowls, put the flour in one bowl, the eggs and water in a second shallow dish, and the panko with the oil in a third shallow dish.

7. Dip the chicken strips in the flour, then the eggs, then panko. Press the strips into the panko to ensure the chicken is evenly coated.

8. Add the chicken strips to a large sheet pan that is greased or lined with parchment.

9. Bake for 15 minutes and then carefully flip each piece of chicken over. Continue baking for an additional 10 to 15 minutes or until the chicken is cooked to 165°F (74°C) internally.

10. Once complete, toss the warm tenders in the sauce mix with the cold butter.

11. Toss until the butter is melted and tenders are well-coated and serve.

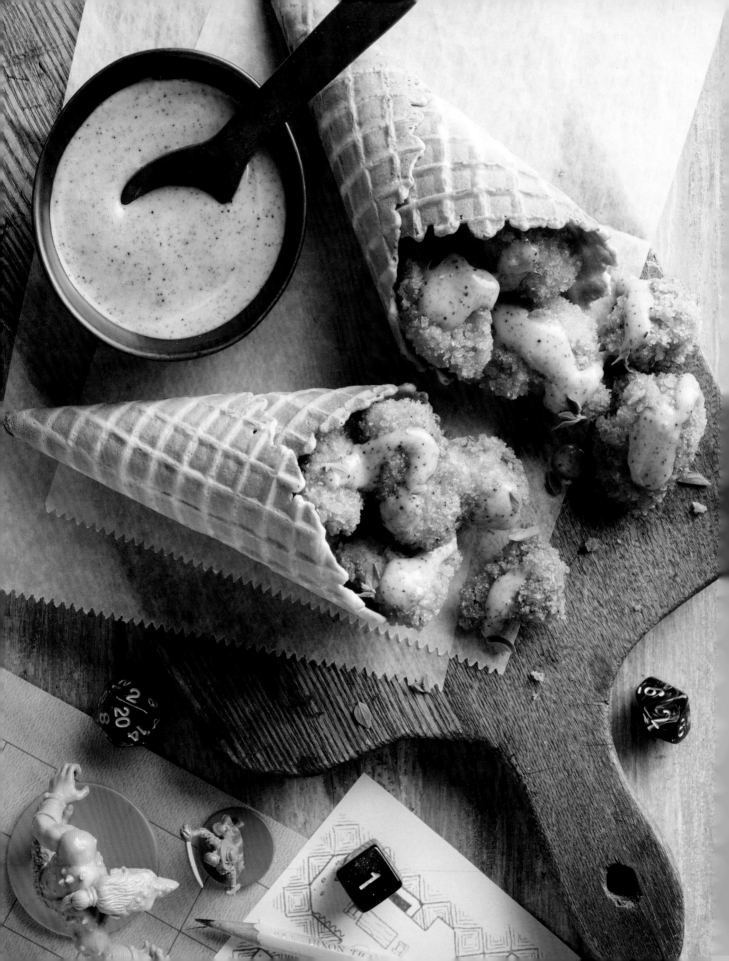

PWNED CONES

Chicken and waffles are the ultimate food pairing. Therefore, bringing popcorn chicken and waffle bites together is a natural evolution. While I do favor making the chicken from scratch, I fully understand the need to use frozen or premade items. No matter how you tackle it, it's a crowd-pleaser, but it's also a bit of a game-pausing dish since it's devoured quickly. No one is immune to the power of waffles. NO ONE!

KardaChef Level: Type 2 • Prep Time: 12 to 24 hours • Rest Time: 5 minutes
Cook Time: 50 minutes • Yield: 10 cones

SEASONING

2 tablespoons (25 grams) chili powder

1 tablespoon (12 grams) ground cumin

2 tablespoons (25 grams) kosher salt

1 teaspoon (6 grams) ground black pepper

2 tablespoons (25 grams) paprika

1 teaspoon (6 grams) dried oregano leaves

2 teaspoons (12 grams) garlic powder

2 teaspoons (12 grams) onion powder

BRINE

½ cup (100 grams) salt

2 quarts (2 liters) sweetened iced tea

1 whole orange, thinly sliced

6 boneless, skinless chicken thighs, about 24 ounces (680 grams), cubed

2 cups (500 milliliters) buttermilk or heavy cream

TO MAKE THE SEASONING

1. Combine seasoning ingredients.

2. Mix well.

3. Set aside, reserving 1 tablespoon (12 grams) separately for the aioli.

TO MAKE THE BRINE

4. In a large bowl or pot, add the salt, sweet tea, oranges, and chicken.

5. Brine for a minimum of 12 hours up to a maximum of 48 hours.

6. Once done brining, remove the chicken, rinse off the brine, and pat dry with a paper towel.

7. Cut the chicken into bite-size pieces.

8. Season the chicken with the seasoning mix.

9. Pour the buttermilk over the top of the chicken and make sure it's all coated. Set aside.

Continued on next page.

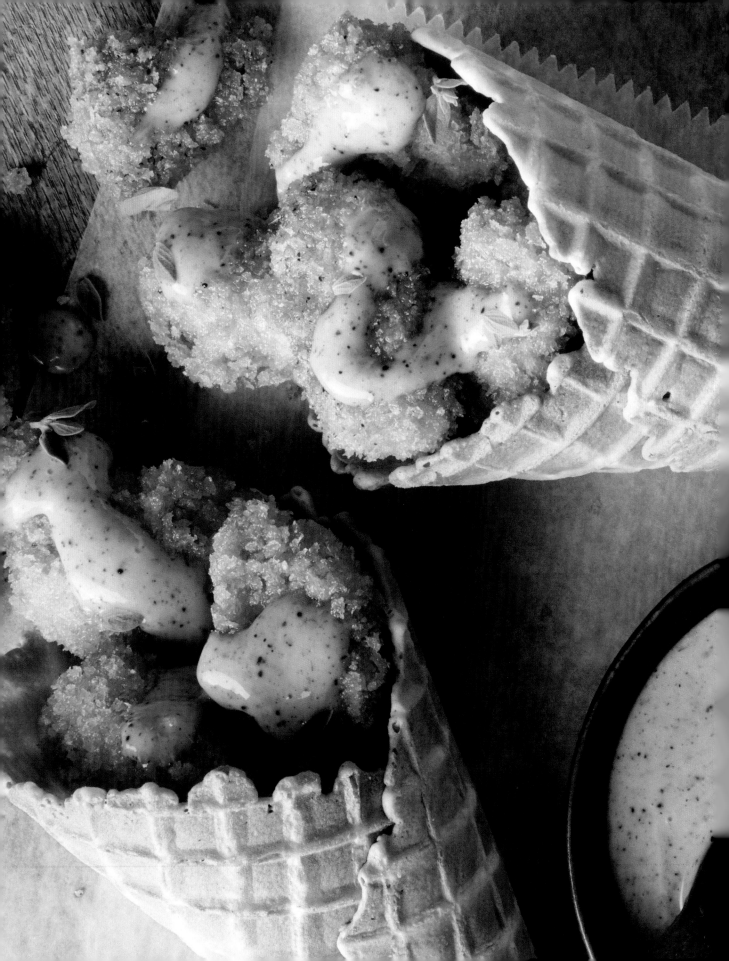

Aioli

1 cup (250 milliliters) mayonnaise

¼ cup (60 milliliters) lemon juice

1 tablespoon (28 grams) seasoning (page 81)

2 tablespoons (30 milliliters) maple syrup

Chicken

4 cups (400 grams) all-purpose flour, seasoned with salt

4 eggs, beaten

3 cups (600 grams) panko breadcrumbs

2 quarts (2 liters) vegetable or canola oil

1 package or 4 ounces (113 grams) waffle cones or bowls

To Make the Aioli

10. Take a medium bowl and whisk together ingredients. Set aside.

To Make the Chicken

11. In 3 separate bowls, place your flour in one bowl, eggs in another, and breadcrumbs in the third to make the process simple.

12. Preheat 1 inch of oil in a deep-frying pan over medium heat. Adjust the heat to keep the oil at 350°F (177°C).

13. Begin by dredging a piece of chicken into the flour, dust off the excess, follow with the egg wash, and lastly, roll in panko breadcrumbs until evenly coated. Transfer to a platter and repeat. You are free to freeze these at this stage to prep ahead.

14. When ready for frying, fry the popcorn chicken in small batches, leaving space between each piece and flipping as needed.

15. Fry until golden brown and the internal temperature of the meat is 165°F (74°C).

16. Remove the popcorn chicken from the oil and let it rest on a plate lined with paper towels.

17. Place a small dollop of the aioli in the base of a waffle cone.

18. Fill your cone with your chicken.

19. Drizzle the aioli over the top of the chicken and serve.

Level Up!

Buff Your Cones

You can add diced waffles to the cone as well, for extra waffle goodness.

While using store-bought iced tea is fine, if you really want to bring your A game, make your own!

1 gallon (3.78 liters) water

12 bags black tea

2 cups (400 grams) granulated sugar

1. In a large pot, bring the water to a boil.

2. Once boiled, turn the heat off, place the tea bags in water, and steep for 10 minutes.

3. Remove the tea bags and discard.

4. Add the sugar and stir until dissolved. Let cool slightly, transfer to a large, sealable jar, and chill in the refrigerator for 2 hours.

GOATED GRAPES

Grapes in theory live in the realm of "perfect food." This recipe gives grapes a buff and takes it to a level far beyond a fruit salad. These are incredibly bright and something that anyone can make. You can even match your deck to your flavors. The hardest part is choosing the ones you love most.

KardaChef Level: Type Null · Prep Time: 40 minutes · Yield: 50 to 60 grapes

1 pound (450 grams) green grapes

Three 3-ounce (85-gram) boxes powdered gelatin, assorted flavors of choice

Toothpicks for serving

2 cups (500 milliliters) lemon juice

1. Clean and separate the grapes and remove any damaged or spoiled ones.

2. Place the gelatin into 3 small separate bowls, or 3 sealable plastic bags.

3. Stick a toothpick into the vine end of a grape, dip in the lemon juice, and then dip into a flavor of gelatin, being careful to fully coat the grape.

4. Place in a serving bowl and repeat until the grapes are completed.

NERFED NOODLES

It may seem like I'm taking noodles down a notch, but I assure you this recipe takes down the difficulty while buffing the flavor. It's not as challenging to make as traditional noodles, but it will look like it. While I suggest ramen noodles, you could easily use zucchini noodles, angel-hair pasta, or even udon. Giving your guests a simple way to slam noodles after a sweep is invigorating.

KardaChef Level: Type 0 • Prep Time: 15 minutes • Cook Time: 20 minutes
Yield: 8 to 12 servings (varies based on the size of your spoons)

2 quarts (2 liters) beef or vegetable broth

Three 3-ounce (85-gram) packets instant ramen or your favorite noodles

3 tablespoons (43 grams) butter

⅓ cup (78 milliliters) red pepper, diced very small

8 to 12 ramen serving spoons

2 tablespoons (6 grams) chives, cut small

1. In a large stockpot, boil your broth and cook your noodles until tender. Follow the package directions, but noodles can also be al dente. Reserve the broth and keep it warm.

2. Remove the noodles and place into a bowl with 2 tablespoons (30 milliliters) of the broth.

3. Add the butter and the seasoning and mix until the noodles are heavily coated.

4. Place your spoons on a flat surface and prepare to build.

5. Take a spoonful of noodles and, using tongs, chopsticks, or a fork, twist them until you have a tight serving on the spoon. Repeat with all the noodles.

6. Carefully take the warm broth and spoon 1 teaspoon (15 milliliters) of liquid over the top to slightly fill the base of the spoon.

7. Sprinkle chives and red pepper on top and serve.

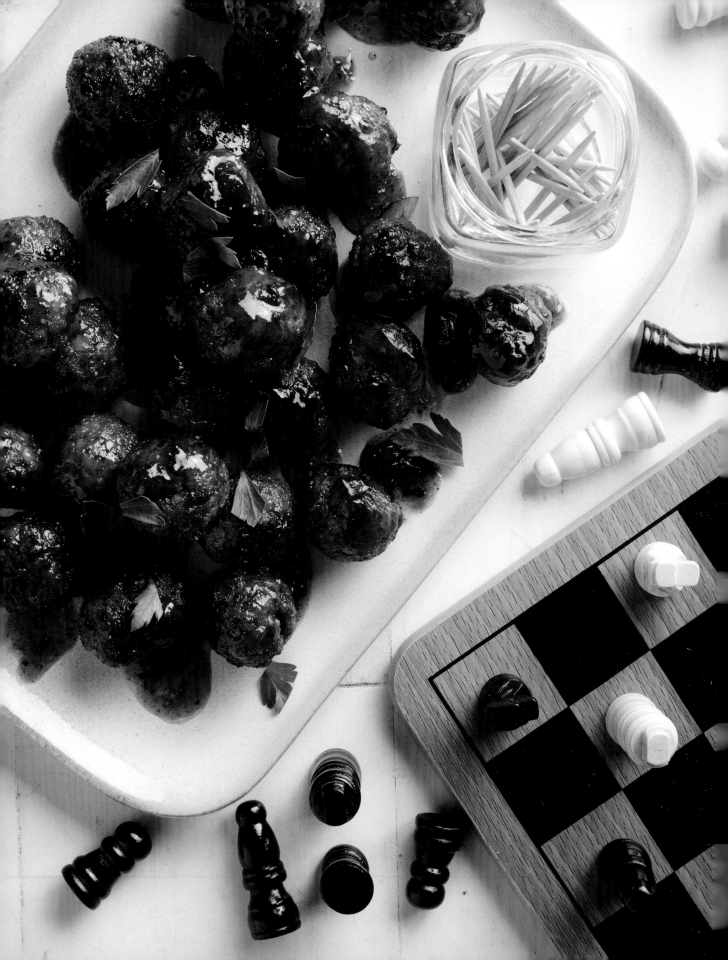

SUPER MEATBALL FORKS

This is an extremely simple dish. Make a meatball, put it on the fork. I'm going to give you a recipe below for meatballs, but I challenge you to ignore me. Use your own recipe, use Nonna's recipe, but I in no way want to make "meat on fork" any more complicated.

KardaChef Level: Type 2 • Prep Time: 1 hour • Cook Time: 15 to 20 minutes • Yield: 24 meatballs

1 pound (450 grams) ground beef (85/15 or 80/20)

¼ cup (40 grams) panko breadcrumbs

2 tablespoons (30 milliliters) extra-virgin olive oil

½ cup (26 grams) grated onion

½ cup (45 grams) grated Parmesan cheese

2 tablespoons (28 grams) kosher salt

2 tablespoons (9 grams) garlic powder

1 egg

Wooden cocktail forks or toothpicks for serving

1 cup (315 grams) strawberry jam (or BBQ sauce if you prefer)

1. Preheat your oven to 400°F (204°C).

2. Line a baking sheet with parchment paper.

3. Mix all the ingredients together except for the jam. Stir gently and be careful not to overmix.

4. Use a tablespoon or small ice-cream scoop to measure out the mini meatballs.

5. Add some oil to your hands, then roll meat into little balls. Spread them evenly on the baking sheet, then spray again with oil.

6. Bake for 15 minutes or until they are browned and slightly crispy. The juices should run clear.

7. Remove from the oven and allow to rest for 5 minutes.

8. When ready to serve, place a fork (or toothpick) in each meatball.

9. Using a small spoon, place a pool of sauce or jam on a large plate.

10. Place the meatballs on the plate in the pool.

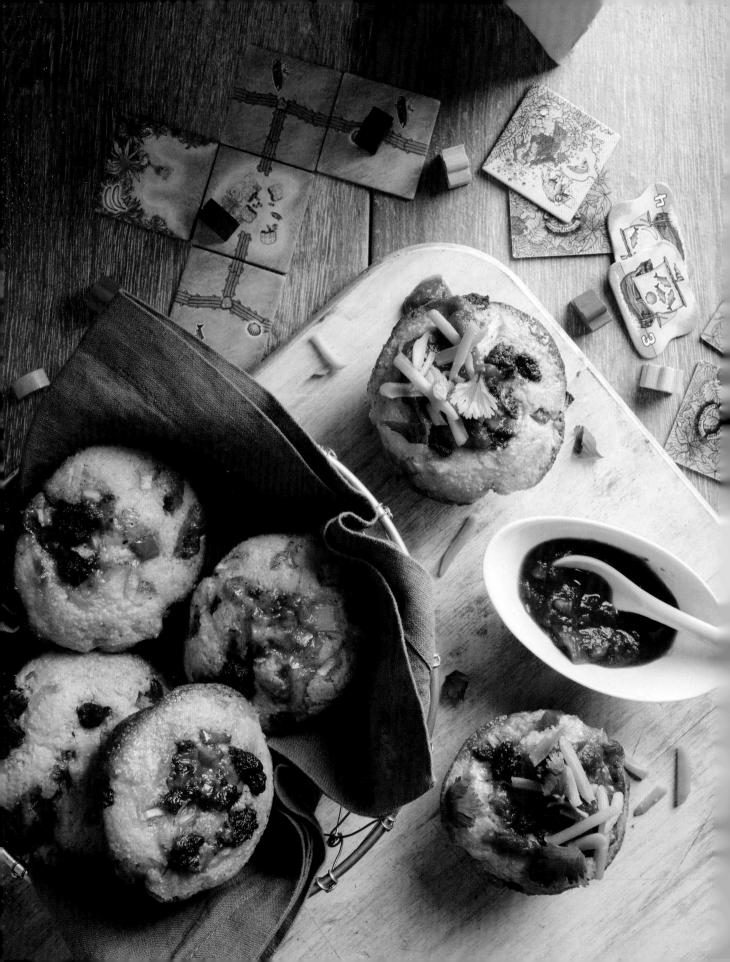

TTK Taco Muffins

Tacos good, clean cards good, meat good. Tacos while playing anything = not good. The only time serving tacos at game night is a good idea is when no one has to touch anything. Do the right thing; make muffins.

KardaChef Level: Type 2 • Prep Time: 1 hour • Cook Time: 20 to 25 minutes • Yield: 12 Muffins

1 pound (450 grams) ground beef

One 1-ounce (28-gram) package taco seasoning

1 cup (201 grams) shredded cheddar cheese

1 jalapeño, chopped small

1 medium onion, chopped small

One 8.5-ounce (240-gram) package yellow cornbread mix

⅓ cup (78 milliliters) milk

1 egg

½ cup (100 grams) shredded jack cheese

Cooking spray

1 cup (250 milliliters) sour cream

2 tablespoons (7 grams) green onions, diced

1. In a large, heavy-bottomed stew pot, cook your ground beef until brown and slightly crispy, about 15 minutes. Drain the liquid.

2. Add the taco seasoning and cook until the beef is well-coated in the seasoning, about 5 minutes. Remove the meat and allow it to cool fully.

3. Once cooled, add the cheddar cheese, jalapeño, and onion, then set aside.

4. Make your cornbread mix by combining the cornbread package contents, milk, egg, and cheddar cheese. Whisk until smooth.

5. Grease your muffin tin with cooking spray and preheat the oven to 400°F (204°C).

6. Pour batter into each muffin well until half the well is full.

7. Take a pinch of the cooled meat stuffing and place in the middle of the batter; take care to make sure it's not overflowing.

8. Fill the rest of the muffin well with the additional batter right before hitting the top.

9. Place in the oven and bake for 20 to 25 minutes.

10. Allow to cool slightly and place the "muffins" on a plate.

11. Finish the muffins with a dollop of sour cream and green onion on top.

Level Up!

If you prefer to skip the shortcut, you can make your own cornbread from scratch.

1 cup (120 grams) all-purpose flour

1 cup (120 grams) yellow cornmeal

1 teaspoon (4 grams) baking powder

1 teaspoon (4 grams) salt

2 tablespoons (25 grams) sugar

1 cup (237 milliliters) buttermilk

½ cup (113 grams) unsalted butter, melted

2 eggs

½ cup (64 grams) shredded cheddar cheese

1 cup (128 grams) shredded jack cheese

1. In a large bowl, combine flour, cornmeal, baking powder, salt, and sugar.

2. In another bowl, whisk together buttermilk, butter, and eggs.

3. Pour wet mixture over dry ingredients and, using a rubber spatula, stir until just combined.

4. Add shredded cheeses, and gently fold to combine.

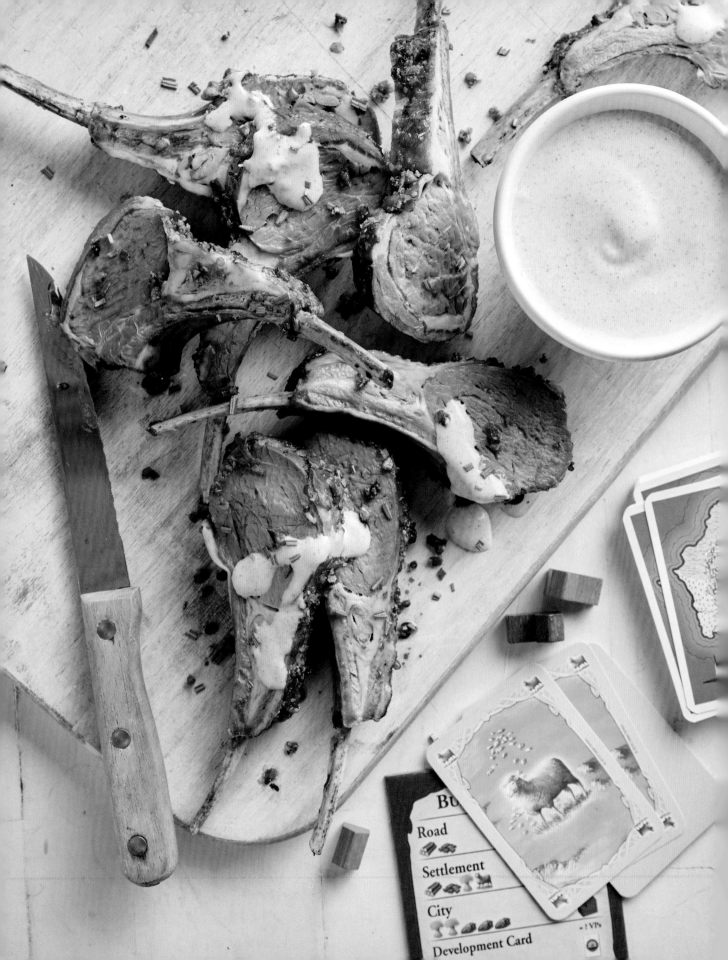

WOOD FOR SHEEP

Manage your resources better.

KardaChef Level: Type 2 • Prep Time: 15 minutes
Rest Time: 24 to 48 hours • Cook Time: 18 to 25 minutes • Yield: 16 servings

1 cup (250 milliliters) extra-virgin olive oil

½ cup (125 milliliters) high-quality balsamic vinegar

6 cloves garlic, minced

½ bunch rosemary, chopped

3 tablespoons (45 grams) salt

1 tablespoon (15 grams) brown sugar, or 2 tablespoons (30 grams) raspberry or strawberry jam

2 racks or about 2 pounds (900 grams) lamb chops, cleaned and fat cap removed

Finishing Sauce

1/2 cup (118 milliliters) mayonnaise

3 tablespoons (44 milliliters) Dijon mustard

1 tablespoon (14 milliliters) lemon juice

1. Add oil, balsamic vinegar, garlic, rosemary, salt, and sugar (or jam) into a blender. Blend until smooth.

2. In a resealable plastic bag or a large bowl, pour the marinade over the lamb and marinate for a minimum of 24 hours up to 48 hours.

3. Preheat your oven to 450°F (232°C) or your grill to high.

4. Place the lamb on a roasting pan, or a rack-lined sheet tray. Cook until the internal temperature is 135°F (57°C), about 8 to 10 minutes on the grill, or 15 minutes in the oven. Turn the lamb over and then cook for another 10 minutes. Allow the lamb to rest.

5. In a small bowl, mix the mayonnaise, mustard, and lemon and set aside.

6. After the lamb is rested, cut into bite-size chops.

7. Drizzle the finishing sauce over the lamb and serve.

Pro Tip

The fat cap means the tough layer of fat on the top of the meat.

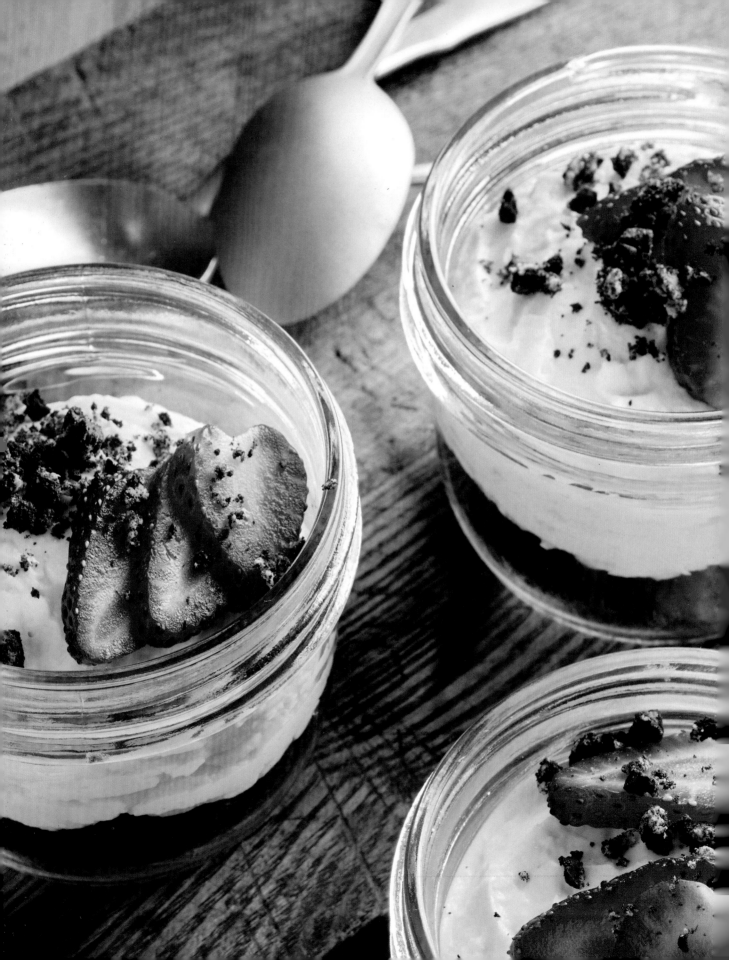

JARRING CIRCUMSTANCES

Good preparation can mean the difference between a win and a loss. In this section, each recipe is designed to be prepared in advance, or even the day before, giving you more time to get your strategy together. Jars are simple to eat out of, work as an easy-to-store-and-carry vessel, and can be given as a gift to your guests; just be sure they don't feel the need to smash them.

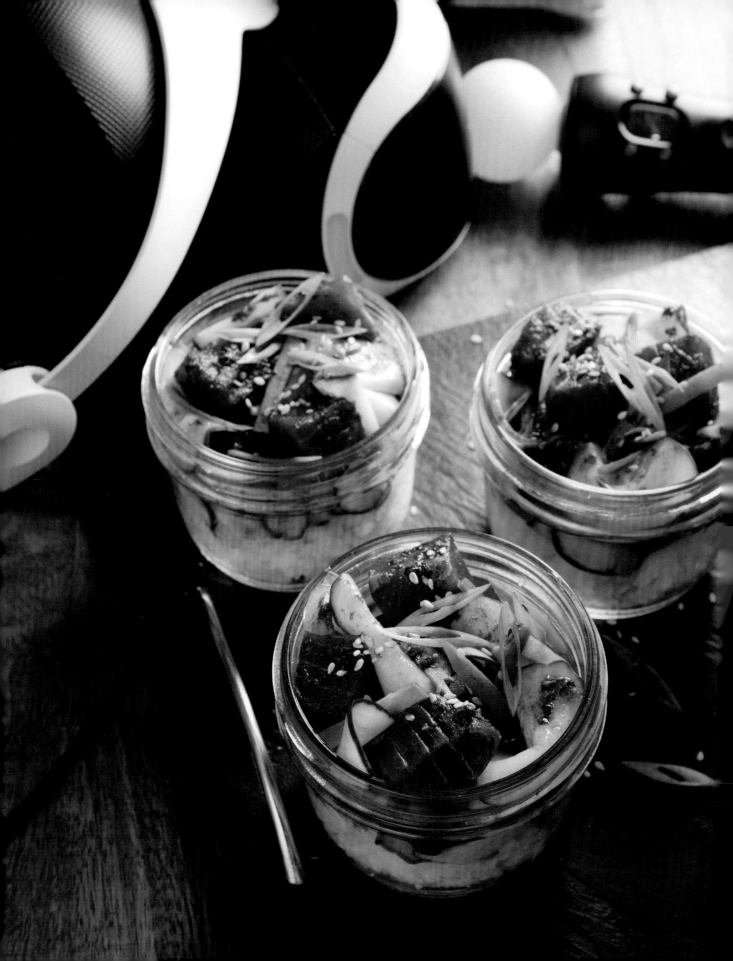

RNG JARS

Of all the recipes in this book, this is the most customizable. I encourage you to ignore this recipe and make it your own like you would spec out your favorite build. Below, I chose poke jars with raw tuna, but you could go with tofu, cooked baby shrimp, lump crab or imitation crab meat, or even make the entire jar vegetables.

KardaChef Level: Type 1 • Prep Time: 30 minutes • Rest Time: 2 to 12 hours
Cook Time: 50 minutes • Yield: 6 to 8 jars

Veggies

1 cup (250 milliliters) water

½ cup (125 milliliters) apple cider vinegar

2 tablespoons (25 grams) sugar

1 teaspoon (6 grams) salt

½ English cucumber, sliced into thin half-moons

3 whole radishes, thinly sliced

1 large carrot, shredded small, about 1 cup (18 grams)

Tuna

1 pound (450 grams) tuna, cut into bite-size pieces

2 green onions, thinly sliced, plus more for garnish

¼ cup (60 milliliters) soy sauce

2 teaspoons (10 milliliters) rice vinegar

2 teaspoons (10 milliliters) sesame oil

1 teaspoon (12 grams) freshly grated ginger

1 teaspoon (12 grams) grated garlic

1 tablespoon (15 grams) chili paste

2 teaspoons (25 grams) salt

Assembly

3 cups (630 grams) cooked white rice

1 teaspoon (15 grams) toasted sesame seeds

2 green onions, sliced thin

Six to eight 8-ounce (236-milliliter) glass jars

To Make the Veggies

1. In a small bowl, add the water, vinegar, sugar, and salt.

2. Stir to combine until the sugar and salt have dissolved.

3. Add the cucumber, radish, and carrots.

4. Add plastic to the top of the mix and make sure vegetables are completely submerged.

5. Let the mixture rest in the fridge until ready to build. Overnight soak is optimal, 2 hours is minimal.

To Make the Tuna

6. In a large bowl, add tuna, green onion, soy, rice vinegar, sesame oil, ginger, garlic, chili paste, and salt.

7. Mix until fully coated.

8. Taste for seasoning.

9. In a separate bowl, add pickled veggie mix to the tuna to prepare for building.

To Assemble

10. Layer a spoonful of rice to line the bottom of the jar.

11. Add a spoonful of the tuna-veggie mix to make a large layer on top.

12. Sprinkle with sesame seeds and garnish with green onions.

13. Serve with a small spoon or chopsticks.

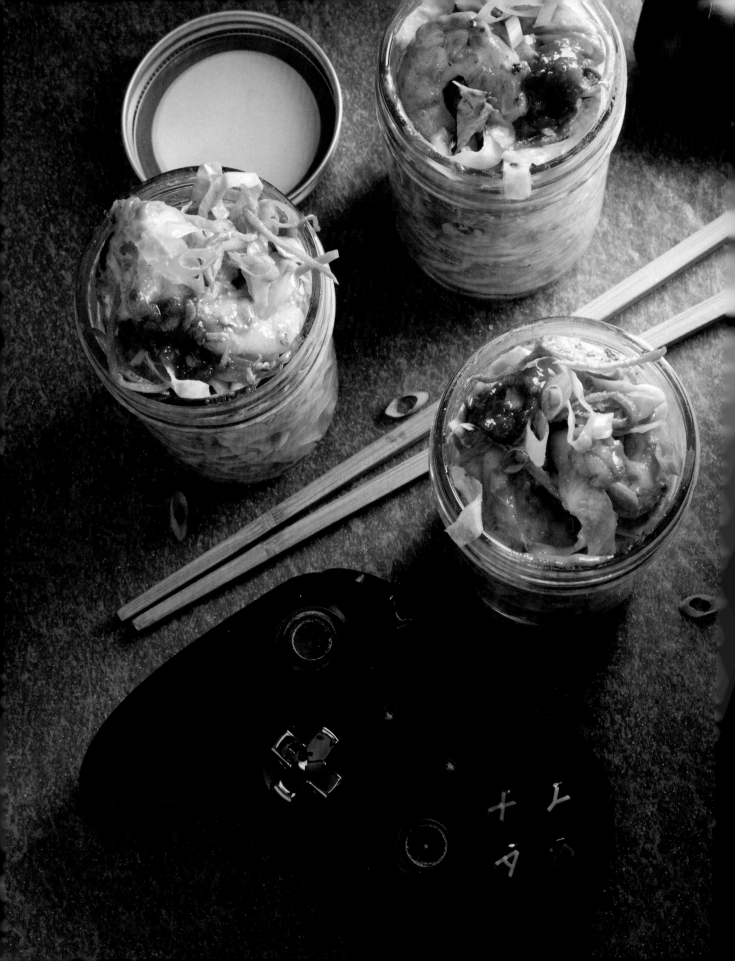

RAID-READY NOODLE SALAD

Know your class, max your gear, max out supplies, be on time. Preparation is the foundation of a solid raid experience. It has huge benefits for you at home solo, or with your group. You can easily grab a jar when you need a clean eating break.

KardaChef Level: Type 1 • Prep Time: 40 minutes • Rest Time: 1 to 12 hours • Cook Time: 20 minutes • Yield: 6 to 8 jars

SAUCE

½ cup (125 grams) peanut butter

3 tablespoons (45 milliliters) water

3 tablespoons (45 milliliters) soy sauce

2 tablespoons (45 milliliters) sesame oil

2 tablespoons (30 milliliters) honey

⅓ cup (78 milliliters) lime juice

3 cloves garlic

¼ cup (66 grams) chili sauce

NOODLES

13-ounce (90-gram) bundle soba noodles

2 tablespoons (30 milliliters) vegetable or sesame oil

12 ounces (340 grams) 26/30 size shrimp

Salt to taste

4 cloves garlic, minced

1 tablespoon (28 grams) minced ginger

½ cup (120 grams) shredded ginger

1 cup (110 grams) shredded carrots

2 cups (400 grams) shredded Napa cabbage

2 scallions, chopped on a bias

Six to eight 8-ounce (236-milliliter) glass jars

TO MAKE THE SAUCE

1. Add all ingredients to a blender and mix until smooth. Add a splash of water 1 teaspoon (15 milliliters) at a time if the mix is too thick.

2. Set aside.

TO MAKE THE NOODLES

3. Bring a large stockpot of water to boil and cook noodles according to package instructions, or until al dente, and remove from heat.

4. Rinse the noodles with cold water to stop the cooking, then add a bit of oil to prevent sticking.

5. Set aside.

6. In a sauté pan, add oil and set to medium-high heat.

7. Add the shrimp, season with salt, and heat until cooked internally, about 4 to 6 minutes. When done, the shrimp will have turned pink and opaque.

8. Add garlic, ginger, carrots, and cabbage.

9. Cook for 1 minute until fragrant. (That means you can smell the garlic.)

10. Add ¾ of the sauce on hand and reserve the rest.

11. Sauté the mix until warm, then remove from the heat. Taste for seasoning and add more if needed.

12. Allow the mix to chill in the fridge for at least 1 hour or overnight.

13. When ready to serve, add the reserved mix of sauce to the noodles.

14. Using a pair of tongs, fill each jar with the shrimp and noodles.

15. Garnish with scallions.

One-Shot Shrimp

When you only have time for one session, this is the way to go. A solid option that can act as a meal for some, or an appetizer for others—the sweet and tangy combo is no slouch when combined.

KardaChef Level: Type 2 • *Prep Time: 35 minutes*
Cook Time: 18 minutes • *Yield: 6 to 8 jars*

Shrimp

2 tablespoons (25 grams) ginger powder

2 tablespoons (25 grams) garlic powder

3 tablespoons (36 grams) paprika

2 tablespoons (25 grams) salt

2 tablespoons (25 grams) brown sugar

1 tablespoon (15 milliliters) vegetable or sesame oil

24 jumbo shrimp, peeled, cleaned, and tails on

12 strips bacon

Six to eight 8-ounce (236-milliliter) glass jars

Cocktail Sauce

1 cup (250 milliliters) ketchup

¼ cup (60 milliliters) sriracha

3 tablespoons (45 milliliters) horseradish

1 bunch cilantro, chopped small

¼ cup (60 milliliters) lime juice

To Make the Shrimp

1. Preheat oven to 400°F (204°C). In a bowl, mix the ginger, garlic, paprika, salt, and brown sugar.

2. Add oil to the shrimp and proceed to season with the spice mix and set aside.

3. Take your bacon and cut your 12 strips in half crosswise.

4. Carefully wrap each shrimp with a single strip of bacon, taking care to pull the bacon so it's wrapped tightly.

5. On a lightly greased roasting pan, add your shrimp and roast 15 minutes or until the bacon is crispy.

To Make the Cocktail Sauce

6. Mix all ingredients in a small bowl and whisk until incorporated.

To Assemble

7. Spoon the cocktail sauce into the base of the jars.

8. Using the edge of each jar, place the shrimp to create a wreath, about 4 to 5 shrimp per jar and serve.

NPC
(NON-PROBLEMATIC CHEESECAKE)

Let's say this is your first time playing with a group. You don't know a majority of the players, you don't know their style, and you really want to impress. Aside from playing poorly, the one thing you're most afraid of is not feeling like you fit into the main group. You want to make sure you have a strong campaign. This recipe is a simple and solid way to make sure you're not just a bystander.

KARDACHEF LEVEL: TYPE 2 · PREP TIME: 40 MINUTES · REST TIME: 2 HOURS · YIELD: 6 TO 8 JARS

CRUST

1 sleeve Oreo cookies

2 teaspoons (8 grams) granulated sugar

1 pinch salt

4 tablespoons (57 grams) butter, melted

FILLING

1 cup (237 milliliters) heavy whipping cream

⅓ cup (43 grams) powdered sugar

1 teaspoon (5 milliliters) vanilla extract

1 tablespoon (15 milliliters) lemon extract

1 teaspoon (2 grams) fresh lemon zest

⅛ teaspoon (1 gram) salt

8 ounces (226 grams) cream cheese, at room temperature

Six to eight 8-ounce (236-milliliter) glass jars

TO MAKE THE CRUST

1. Remove cream center from Oreos and set cream aside to add to cheesecake mix.

2. Using a food processor, or by hand, crush the cookies into crumbs.

3. Add salt and mix with the melted butter.

4. Mix together until it's easy to clump together.

5. Line the bottom of your jars with the mix—your preference of cookie crust is up to you (graham cracker, chocolate chip, or even vanilla crème).

6. Chill in the fridge while you prepare the filling.

TO MAKE THE FILLING

7. Add the heavy cream and sugar to a large mixing bowl.

8. Beat using a hand mixer on medium until the whipped cream creates stiff peaks. Set aside.

9. In a separate large mixing bowl, add the vanilla, lemon extract, zest, and salt into the cream cheese and the cookie cream you set aside, then beat until smooth.

10. Fold half of the whipped cream into the cream cheese mixture.

11. Once incorporated, fold in the remaining whipped cream.

12. Add the cheesecake mixture into a piping bag or resealable plastic bag.

TO ASSEMBLE

13. Pipe the mixture evenly into about 6 mason jars.

14. Chill for a minimum of 2 hours before serving.

15. Serve with fresh fruit or whipped cream over the top.

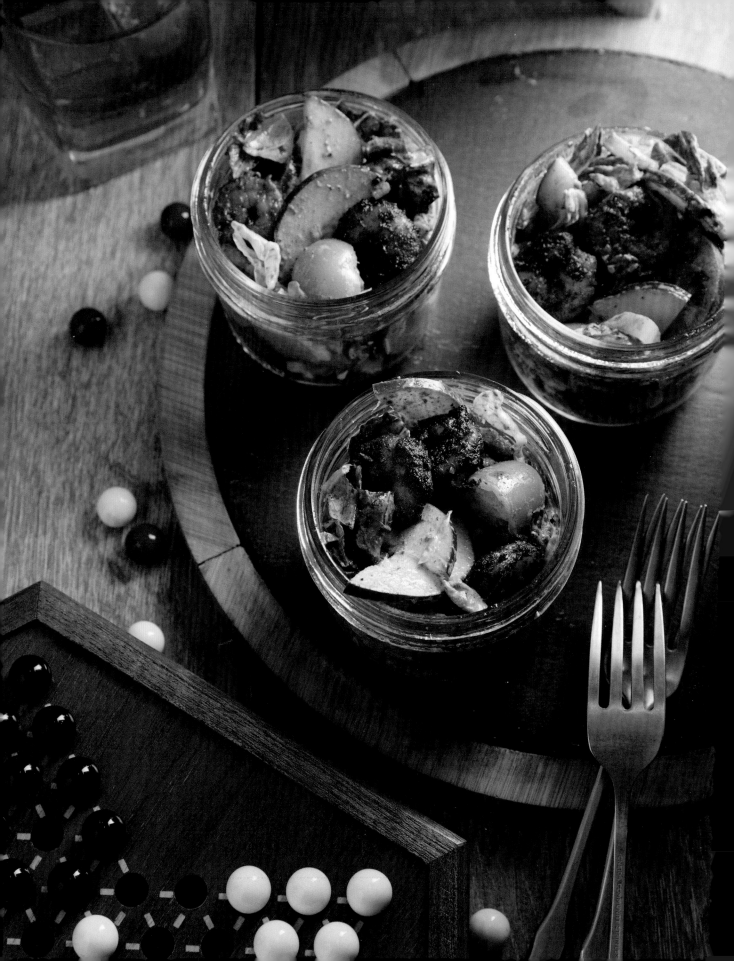

BLACKENED SHRIMP SALAD

It's very easy to make this recipe for your co-op partner, or for the entire guild. Served chilled, hot, warm, or even refrigerated overnight, the shrimp will remain delicious with the dressing. I cannot say the same about your partner if you lose.

KardaChef Level: Type 1 • Prep Time: 40 minutes • Cook Time: 20 minutes • Yield: 6 to 8 jars

Seasoning

2 tablespoons (28 grams) paprika

2 tablespoons (28 grams) onion powder

1 tablespoon (14 grams) garlic powder

1 tablespoon (14 grams) cumin

1 tablespoon (14 grams) salt

1 tablespoon (14 grams) black pepper

1 tablespoon (14 grams) Italian seasoning

1 teaspoon (6 grams) dried ground oregano

¼ to ½ teaspoon (2 to 4 grams) cayenne, adjust to your heat index

Shrimp

One 16-ounce bag (454-gram) baby shrimp or small shrimp cut in half, deveined

2 fresh limes, juiced

1 pinch salt

1 tablespoon (14 grams) butter

1 large English cucumber, cut into thin half-moons

1 cup (128 grams) cherry tomatoes, halved lengthwise

1 head romaine lettuce, thinly shredded

Dressing

1 cup (230 grams) mayonnaise

⅓ cup (118 milliliters) lemon juice

2 tablespoons (30 milliliters) Tabasco, or your favorite hot sauce

1 tablespoon (14 grams) paprika

1 tablespoon (14 grams) of the reserved seasoning mix

Six to eight 8-ounce (236-milliliter) glass jars

To Make the Seasoning

1. Mix all ingredients in a small bowl; set aside and reserve 1 tablespoon (14 grams) for the dressing.

To Make the Shrimp

2. In a medium bowl, take your cleaned shrimp and add 2 tablespoons (30 milliliters) of oil.

3. Add your seasoning mix to the shrimp and thoroughly coat.

4. Let this sit refrigerated for 30 minutes while you prep your vegetables.

5. To cook the shrimp, take a heavy frying pan (cast iron is ideal) and add remaining 2 tablespoons (30 milliliters) of oil.

6. Sear the shrimp on high until they are pink and opaque, for about 3 minutes on each side.

7. Remove from the heat and add the lime juice, salt, and butter and mix until butter is melted.

8. You can serve this hot on top of the cool salad, or chilled.

To Make the Dressing

9. Mix mayonnaise, lemon juice, hot sauce, paprika, and reserved seasoning mix and whip until blended.

To Assemble

10. Mix the shrimp with the mayonnaise dressing and taste for seasoning.

11. In a separate bowl, mix the cucumber, tomato, and romaine together.

12. Add the shrimp in with the salad mix and gently mix until incorporated.

13. Using a spoon, small tongs, or chopsticks, spoon a healthy portion of mix into each jar.

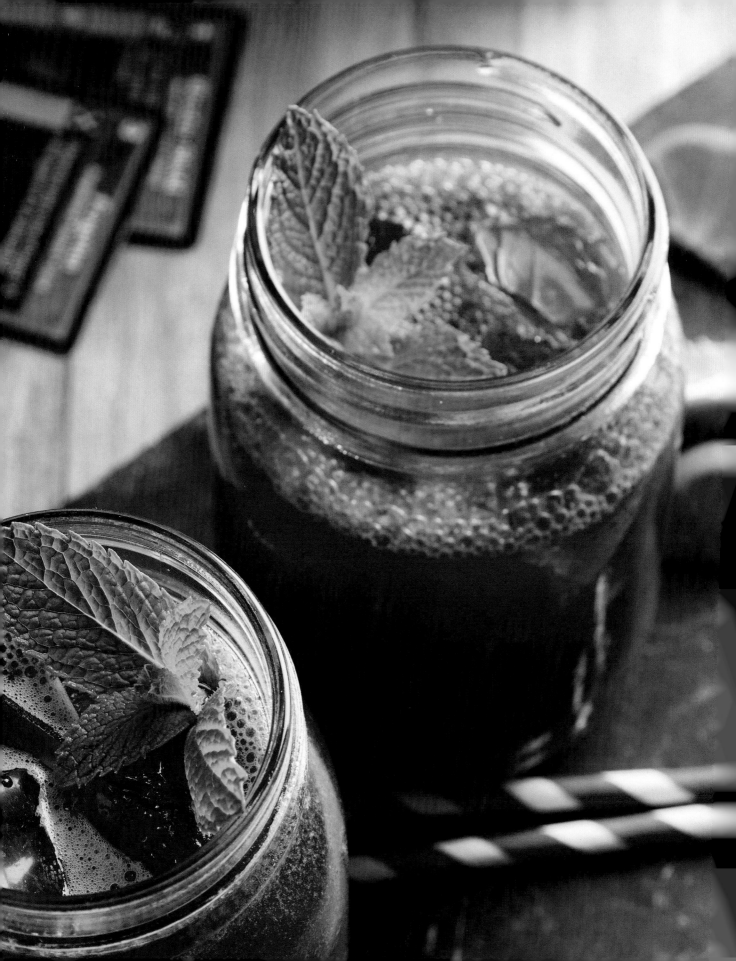

SWEET VICTORY

What do games and baking have in common? You must follow the rules! Baking is a science and it must be exact! That being said, please feel free to ignore every single word I'm going to say for these dishes. Every recipe in this section is built to allow you to improvise and adjust the recipe. Like creating your perfect build, or tailoring your deck, this is the time to make it yours.

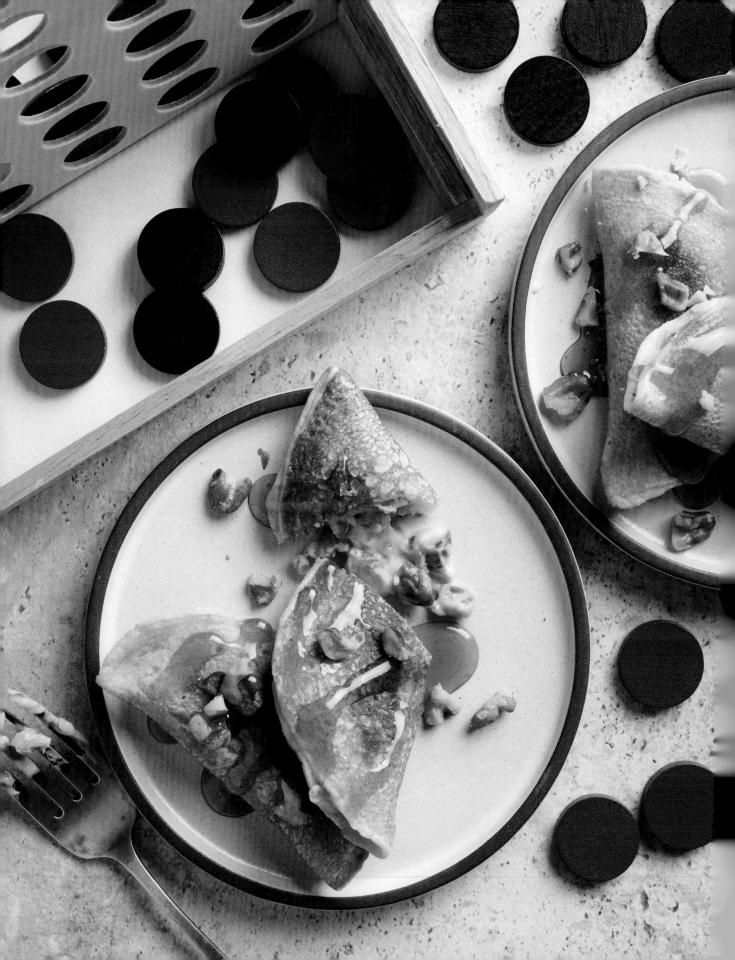

Command Point Pancakes

This recipe and method are close to my heart. I learned this method from a family I used to cater for every year. I likely used this entire book as an excuse to make sure more folks made this. If you're on a solo run in the morning, this is the perfect bite-size breakfast to enjoy with chopsticks.

KardaChef Level: Type 0 • Prep Time: 15 minutes • Rest Time: 20 minutes
Cook Time: 20 minutes • Yield: 30 pancakes

Simple Syrup

1 cup (250 milliliters) maple syrup

¼ cup (60 milliliters) water

2 sprigs mint

Stuffing

One 8-ounce (227-gram) block cream cheese, softened or whipped

1 cup (200 grams) chopped small walnuts

5 tablespoons (100 milliliters) maple syrup

To Make the Simple Syrup

1. In a small saucepan, combine the sugar and water and place over medium heat.

2. Bring the mixture to a simmer and lower the heat a bit. Cook over low heat, stirring frequently, for about 5 minutes, at which time the sugar should have completely dissolved and the syrup started to thicken.

3. Let cool and then pour into an airtight container for storage; it can be kept for up to 2 weeks.

To Make the Stuffing

4. In a small bowl, use a spoon or a mixer to whip the cream cheese until smooth.

5. Add the walnuts and maple syrup and fold until fully incorporated.

Continued on next page.

Pancakes

2 cups (473 milliliters) warm milk

1 cup (200 grams) all-purpose flour

½ cup (100 grams) fine semolina

2 tablespoons (25 grams) granulated sugar

1 teaspoon (6 grams) baking powder

½ teaspoon (3 grams) active dry yeast

½ teaspoon (3 grams) salt

Sprigs of mint, for garnish

To Make the Pancakes

6. Starting with the warm milk, add all ingredients to a blender.

7. Blend on low until fully mixed and set aside for 20 minutes. The batter should be thin and runny.

8. Using a warm skillet or frying pan, lightly grease it and set to medium-low heat.

9. Pour large spoonfuls, about 2 tablespoons (30 milliliters) each, of batter on the pan, being careful to not allow the pancakes to touch.

10. Cook until you notice the bubbles appearing, about 3 minutes, but do not flip!

11. Remove each pancake and place them on a sheet pan with the cooked side down.

12. Place a good-sized spoonful of stuffing into the pancake, being careful not to overfill.

13. Gently fold the pancake in half over the stuffing, creating a half-moon, and pinch the sides to crimp along the edge.

14. After completed, prepare to bake or deep-fry the pancakes, deep-frying at 350°F (177°C) until golden brown, about 3 to 4 minutes. If baking, bake at 375°F (190°C) for 20 minutes.

15. Remove from the heat and drizzle the simple syrup over the top of each pancake. Garnish with sprigs of mint.

DIVINI-TEA

Inflicts major holy damage to enemies and buffs allies. Can be paired with elemental snacks to deal additional status effects like Regen, Haste, and Protect.

KardaChef Level: Type 0 • Prep Time: 10 minutes • Yield: 6 drinks

3 limes cut into quarters

1 lime cut into slices for garnish

2 bunches of mint leaves, about 30 in total

1 cup (236 milliliters) honey

1 quart (945 milliliters) hot water

5 bags of basic green tea

One 12-ounce (335-milliliter) can of lemon-lime soda

3 ounces (85 grams) cucumber, sliced very thin

2 cups (472 grams) ice

1. Boil the water, remove from the heat, and add the tea bags. Allow to steep for 10 minutes to make a strong green tea.

2. Remove the tea bags and add the honey, then mix thoroughly until the honey is dissolved.

3. Add the ice and chill for 30 minutes. Alternatively, place in the refrigerator and chill.

4. Bring out your glasses and add 2 limes and a pinch of mint leaves into each glass, about 5 to 7 leaves per glass. Using a mulling tool or a spoon, mash the lime and mint together for about 10 seconds.

5. Take your sweet tea mix and pour it over the top of the muddled fruit. Fill each glass ¾ of the way to the top.

6. Top each glass with the lemon-lime soda of your choosing.

7. Garnish with the sliced cucumber, slice of lime, and a mint leaf.

CHERRY LIMEADE

In almost every group, there are times when not everyone is getting along during a session. You may have folks on their phone not paying attention, someone may not know the right time to stop talking, or you may have that one person who blames every single bad move on the game, luck, or the rules. Before you end up flipping the table, utilize this drink to cool things down when it's a bit too heated. "Mods" are heavily encouraged with this one.

KardaChef Level: Type 0 · Prep Time: 10 minutes · Yield: 4 drinks

2 cups (522 grams) jarred cherries with syrup

1 cup (250 milliliters) lime juice

¼ cup (60 milliliters) maple syrup or honey

1 cup (236 grams) ice

20 sprigs of mint

4 tall glasses

1. Add all ingredients except the mint to a blender.

2. Blend until mixed and slushed.

3. Add 16 sprigs of mint (reserving 4 for garnish) and pulse until lightly chopped in the mix.

4. Add a small amount of ice to each glass.

5. Pour your mix into each glass.

6. Top with a sprig of mint.

CLUTCH CUPCAKES

These cupcakes were created to solve the problems of having cupcake wrappers on the table, and too much frosting on top of cupcakes. You'll look down on other cupcakes after experiencing this "cupcake sandwich" yourself.

KardaChef Level: Type 0 • Prep Time: 15 minutes • Cook Time: 20 minutes • Yield: 6 to 12 cupcakes

Cupcakes

1 cup (150 grams) all-purpose flour (cake flour is optional)

1¼ teaspoons (5 grams) baking powder

⅛ teaspoon (1 gram) salt

½ cup (125 milliliters) whole milk

2 large eggs

¾ cup (150 grams) granulated sugar

¼ cup (60 grams) unsalted butter, melted

2 teaspoons (10 milliliters) vanilla extract

½ teaspoon (25 milliliters) vegetable or canola oil

To Make the Cupcakes

1. Mix flour, baking powder, and salt in a large bowl. Set aside.

2. Place milk in a cup with the eggs and oil, mix, and set aside.

3. In your mixer or bowl, add the sugar and butter, and whip for about 8 minutes on high until smooth and the sugar crystals are no longer visible.

4. Add the milk and egg mix along with the vanilla and blend until incorporated.

5. Set the mixer on low and slowly add your flour mix ½ cup at a time.

6. Scrape down the sides and base of bowl and make sure the batter is fully mixed with no lumps.

7. Preheat the oven to 350°F (177°C).

8. Line your cupcake pan with mini muffin liners, or grease.

9. Fill each cupcake tin up to ⅔ full and be careful to not overfill.

10. Bake for 22 minutes, or until the cupcake passes the clean toothpick test.

11. Allow to cool for up to 30 minutes.

To Make the Chocolate Ganache

12. In a large bowl, place your espresso and chocolate chips.

13. Heat the heavy cream up until nearly boiling.

14. Add the hot cream to the chocolate and stir consistently until fully melted; the mix should look glossy.

15. Using a large spoon, or a cup with a spout, coat each cupcake in chocolate ganache.

16. Allow each cupcake to rest until the chocolate is set and hardened (you can also refrigerate to speed this up).

Skip a Turn

If making from scratch, follow this recipe. If using store-bought cupcakes, move to the ganache stage.

Continued on next page.

Chocolate Ganache

1 tablespoon (5 grams) ground espresso or ground coffee beans

6 ounces (120 grams) semisweet chocolate chips

½ cup (120 milliliters) heavy cream

Whipped Cream

¾ cup (177 milliliters) heavy whipping cream

1 tablespoon (13 grams) granulated sugar

1 teaspoon (5 grams) almond extract

To Assemble

1. Take your ready-made or homemade cupcake, remove any paper base, and cut it in half horizontally.

2. Place a small amount of ganache on the bottom half of each cupcake.

3. Flip the top over and press into the bottom, making a "cupcake sandwich."

4. Then place an additional small amount of ganache on top of each.

5. Set on a wired rack.

To Make the Whipped Cream

6. Combine the whipping cream, sugar, and almond extract. Using a hand mixer, or a whisk, whip until stiff peaks form.

7. Top each cake with a spoonful (or pastry bag piped) dollop of whipped cream. You can add a dusting of espresso powder on top if you want to be extra fancy.

BONUS ACTION BERRIES

You're nearing the end of a campaign, you're low on supplies, and you've just landed a crit. Suddenly, someone blurts out, "Does anyone feel like dessert?" Surely, you're not going to allow the game to stop. Whipping up a quick fix will keep you and your party in the game. And +2 bonus to AC, DM's approval required.

KardaChef Level: Type O • Prep Time: 15 minutes • Yield: 4 servings

BERRIES

3 pints (340 grams) mixed berries: raspberries, blackberries, and quartered strawberries

1 cup (200 grams) granulated sugar

1 lemon, juiced

WHIPPED CREAM

1 cup (250 milliliters) heavy whipping cream

1 lemon, zested

2 tablespoons (30 grams) sugar

1. In a large bowl, place washed berries.

2. Pour sugar and lemon juice, then gently fold; let sit for 10 minutes.

3. Whip the cream with lemon zest and sugar.

4. Fill each bowl with a generous amount of fruit, then top with the whipped cream.

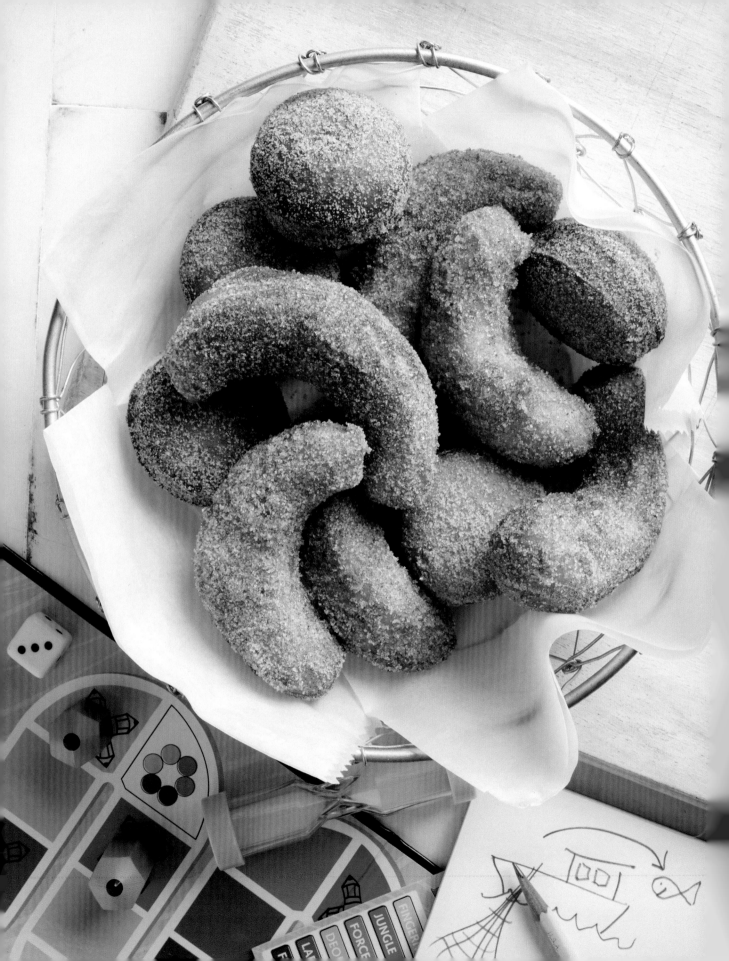

Harvest Half-Moons

This is a recipe I learned from my grandpa, and any greenhorn can handle these delights. Once you inherit this recipe, you will see how easily you can craft these as a gift for that special someone near the community center.

KardaChef Level: Type 2 · Prep Time: 15 minutes · Cook Time: 30 minutes · Yield: 8 donuts and 8 donut holes

3 quarts (2.8 liters) vegetable oil

One 10-count, 12-ounce (340-gram) can of flaky layered biscuits

4 cups (800 grams) sugar

4 tablespoons (45 grams) ground cinnamon

1 teaspoon (6 grams) salt

1. Heat 3 quarts oil in a large, deep skillet or deep fryer to 325°F (162°C).

2. Using a ring cutter (or the cap from a soda bottle), cut the center from each biscuit, then cut the entire donut in half to create half-moons.

3. In a small bowl, combine the sugar, salt, and cinnamon and set aside.

4. Gently place a donut in the pan of hot oil. Use this first donut to test your heat and timing.

5. Fry until golden brown on one side, about 2 minutes, and then flip and fry until golden brown on the other side. Note: If it browns too fast, the oil is too hot.

6. Remove and drain on a plate lined with paper towels. Immediately shake each hot donut in the sugar and cinnamon mixture to coat.

7. Repeat with the remaining donuts.

8. Take the holes you cut out prior and fry those to make donut holes.

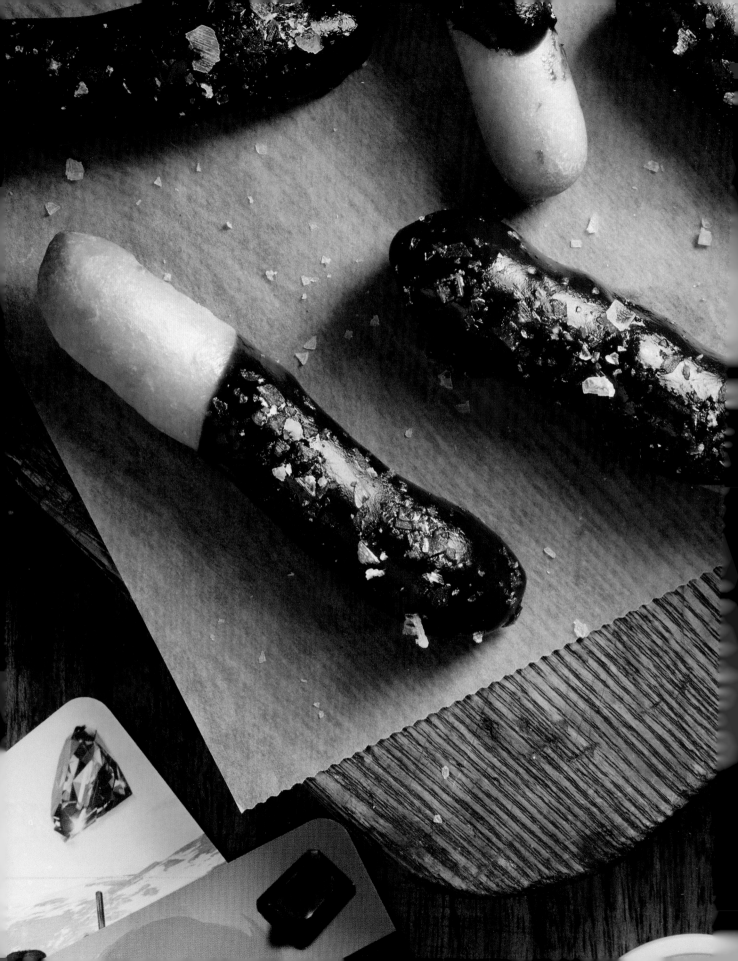

FACTION FRIES

This can easily be your go-to recipe when you have your closer friends over. Your goal in this recipe is to make the fries as thin as possible and eat them with chopsticks or mini forks. This is simply because after the first bite, none of them will intend on sharing. Do yourself a favor and avoid the powdered sugar. Keep things clean.

KardaChef Level: Type 2 • Prep Time: 15 minutes • Rest Time: 5 minutes
Cook Time: 20 minutes • Yield: 10 servings

Cinnamon Sugar Mix

2 cups (400 grams) sugar

2 tablespoons (28 grams) ground cinnamon

Fries

2½ cups (500 grams) all-purpose flour

1 teaspoon (6 grams) baking powder

½ teaspoon (3 grams) salt

2 large eggs

¼ cup (50 grams) sugar

¾ cup (175 milliliters) milk

1 teaspoon (5 milliliters) vanilla extract

3 quarts (2.8 liters) vegetable oil

To Make Cinnamon Sugar Mix

1. In a medium bowl, add cinnamon and sugar and mix until blended into a light brown color and set aside.

To Make Fries

2. In a medium bowl, whisk together the flour, baking powder, and salt.

3. In another bowl, whisk the eggs, sugar, milk, and vanilla together until frothy.

4. Add the flour mixture to the egg mixture and blend until smooth, ensuring no lumps.

5. Add oil to a medium saucepan or deep fryer and heat to 350°F (177°C). Set aside a wire rack or a plate lined with paper towels.

6. Add batter to a squeeze bottle or large piping bag. (You can also use a resealable plastic bag.)

7. Pipe the batter into the hot oil 5 to 7 straight lines at a time. Fry 30 to 60 seconds or until golden brown.

8. Using a mesh strainer or slotted spoon, carefully remove fries to the prepared rack or plate lined with paper towels.

9. Dust with cinnamon and sugar mix. Serve with chopsticks to avoid sticky fingers.

Play Your Alt

Instead of the cinnamon and sugar, try dipping these in the chocolate ganache on page 115 and sprinkling them with a little coarse sea salt, as seen here, for an alternate flavor.

DIETARY CONSIDERATIONS

GF = Gluten Free | V = Vegetarian | V+ = Vegan

ROLL FOR INITIATIVE	GF	V	V+
Thyme to DDDDuel Decker			
Frenzied Finger Sandwiches			
Cucumber Crab			
Turkey Apple			
Vegetable Spread		X	
Strawberry Cheese		X	
Paladin Pizza Puffs			
Bard Sliders			
Baby BLTs (Hold the L)	X		
Cheesesteak Hand Pies			

STABBY STABBY STAB	GF	V	V+
Pass Turn Puffs			
Tortellini Skewers			
Beef of Balance			
Prosciutto-Wrapped Veggies	X		
Peanut Sauce Skewers			
Pancake Skewers		X	
Garlic Lemon Chicken Skewers	X		
Mana Skewers	X	X	X
Druid Snacks	X	X	

122

DLC (DIPS LIKE CHIPS)	GF	V	V+
Beefy Deep			
White Bean Dip	✗	✗	
Bread Loadout			
Tactical Cheese Spread	✗	✗	
Aggro Apple Dip		✗	
Owlbear Dip	✗		
Wild Card Dip			

TURN ORDER TARTS	GF	V	V+
Spinach Artichoke Hearts of Darkness		✗	
PvP Tarts			
Cucumber Hummus Tarts	✗	✗	✗
French Tarts FTW			
Puff Pastry and Prosciutto			
Wonton Nacho Cups			
Bot Lane Biscuits			

SIDE QUESTS	GF	V	V+
Popcorn Variants		✘	
Canteen Kettle Corn		✘	✘
The Third Age Tenders			
Pwned Cones			
GOATED Grapes	✘	✘	
Nerfed Noodles			
Super Meatball Forks			
TTK Taco Muffins			
Wood for Sheep	✘		

JARRING CIRCUMSTANCES	GF	V	V+
RNG Jars			
Raid-Ready Noodle Salad			
One-Shot Shrimp			
NPC (Non-Problematic Cheesecake)		✘	
Blackened Shrimp Salad			

SWEET VICTORY	GF	V	V+
Command Point Pancakes		✘	
Divini-tea	✘	✘	
Cherry Limeade	✘	✘	
Clutch Cupcakes		✘	
Bonus Action Berries	✘	✘	
Harvest Half-Moons		✘	
Faction Fries		✘	

DEDICATION

This book is dedicated to the numerous folks who are no longer with us today, but always inspired my culinary journey. To Marvin, Carmelie, Chef Almquist, Jessica, Kristen, Kevin, Mr. Cote, and Grandpa; I wish I could feed you one last time.

About the Author

They say life is more fun if you play games, and food tastes better with company. If you had to explain Andy Lunique's character, those traits would be the foundation of his build. With a long career in hospitality and his current role in the gaming industry, Chef Andy Lunique has managed to find ways to bridge the gap of food and gaming no matter where he is.

While his days at the Culinary Institute of America were spent going through challenging classes to prepare him for a career as a chef, the nights were spent in the common rooms playing co-op shooters and card games. Wherever there's a party, you can count on Andy being the one in the kitchen making sure everyone is fed; now he aims to level up your skill to do the same.

INSIGHT EDITIONS

PO Box 3088
San Rafael, CA 94912
www.insighteditions.com

Find us on Facebook: www.facebook.com/InsightEditions

Follow us on Twitter: @insighteditions

Library of Congress Cataloging-in-Publication Data available.

ISBN: 978-1-64722-947-4

Publisher: Raoul Goff
VP, Co-Publisher: Vanessa Lopez
VP, Creative: Chrissy Kwasnik
VP, Manufacturing: Alix Nicholaeff
VP, Group Managing Editor: Vicki Jaeger
Publishing Director: Mike Degler
Designer: Brooke McCullum
Executive Editor: Jennifer Sims
Associate Editor: Sadie Lowry
Editorial Assistant: Alex Figueiredo
Managing Editor: Maria Spano
Senior Production Editor: Michael Hylton
Production Associate: Deena Hashem
Senior Production Manager, Subsidiary Rights: Lina s Palma-Temena

Photography by Waterbury

ROOTS of PEACE REPLANTED PAPER

Insight Editions, in association with Roots of Peace, will plant two trees for each tree used in the manufacturing of this book. Roots of Peace is an internationally renowned humanitarian organization dedicated to eradicating land mines worldwide and converting war-torn lands into productive farms and wildlife habitats. Roots of Peace will plant two million fruit and nut trees in Afghanistan and provide farmers there with the skills and support necessary for sustainable land use.

Manufactured in China by Insight Editions

10 9 8 7 6 5 4 3 2 1